Houses
of the
Art Deco Years

Houses
of the
Art Deco Years

Braiswick

Braiswick
61 Gainsborough Road, Felixstowe, Suffolk
IP11 7HS

ISBN 1 898030 71 5

Copyright © 2003 **Jean Gardner**
www.author.co.uk/gardner

The moral right of the author has been
asserted.

British Library Cataloguing in Publication
Data available.

Printed in Kent
by JRDigital Print Services Ltd
Braiswick is an imprint of Author Publishing Ltd

For Janet

whose enthusiasm for all

Art Deco first aroused my interest

Jean Gardner

A member of the Twentieth Century Society, Jean Gardner's main interest is in the houses of the inter-war years. As a child she was brought up among the Thirties estates of North London and was fascinated by the drum shaped Arnos Grove station which served the area.

She lives with her husband Cliff live in Hertfordshire where Art Deco influences permeate almost every town and village. Jean's first book Aviation Landmarks dealt with the history of aviation as
we can see it around us. In this book she reveals how the influences of Art Deco are visible on almost every house built during that period from those on suburban estates to isolated country dwellings.

Contents

Foreword

For most architectural historians, the inter-war suburbs are part of the history of planning and the history of taste, rather than the history of style. it is easy to form a generalised impression of the architectural character of the houses that make up the numerous streets, but within the relatively unchanging envelope of the two-storey semi-detached house there is an extraordinary degree of variety in the design of details.

To analyse these with the rigour that is normally applied to Gothic or renaissance architecture would probably be impossible, but something like Jean Gardner's collection of photographs would be necessary as a first step. Perhaps one could trace influences from one pattern book or building magazine onto the street, or find that one of the houses shown at the Ideal Home exhibition set the trend for a particular kind of stained glass or brick arch. In the end, one would still be amazed at the almost diabolical passion for variety.

I like the way that 'Art Deco' is applied here in a catch-all manner. As the organisers of the Art Deco World exhibition at the Victoria & Albert Museum in the spring and summer of 2003 discovered, it is a difficult term to define, and one either needs to choose a wide or a narrow definition. The architect Peter Smithson once said that Art Deco was a mode rather than a style. I think that what he meant was that you can have an Art Deco version of Tudor, as well as an Art Deco version of Classicism, and an Art Deco version of modern. the architecture of the British suburbs seems to illustrate the point very well, and although Britain

has a few buildings that can be described as 'pure' Art Deco, the impure versions are far more numerous. Like the cocktails that were so much a feature of the lifestyle of the period, these houses are defined by being a mixture. The mixture may sometimes be rather indigestible, but it grabs your attention and tickles your palate, so I raise my straight-sided glass to Jean Gardner's book and its success.

Alan Powers

Introduction

Millions of houses, built at the height of the Art Deco period in the Twenties and Thirties, dominate the suburbs of Britain. Maligned for so long as 'commuterland', they are only just beginning to be appreciated for their distinctive styles and successful contribution to British housing. Indoors, to many people, Art Deco is typified by boldly coloured china, jewellery and furnishings which are now collectables.

Outdoors, the larger suburban buildings, such as streamlined cinemas, are more likely to attract immediate attention, though many have been adapted for other uses, such as bingo halls. But millions of contemporary houses, which were strongly influenced by the Art Deco styles, survive as the comfortable, welcoming homes they were intended to be.

The term 'Art Deco', originates from an exhibition of decorative arts held in Paris in 1925, when art movements from many countries displayed their creations in twelve exotic pavilions. The chief requirement was that the designs should be innovative. Consequently the displays varied enormously with contrasting characteristics vying for attention. Symmetrical and asymmetrical designs stood side by side. Stylised motifs and bright colours were common, together with zig-zags and abstract geometric patterns.

Moorish and Aztec Indian influences prevailed but were strongly challenged by those based on Japanese art. After the discovery of the Tomb of Tutankhamen in 1921, Egyptian styles became highly fashionable and were the highlight of the 1925 Wembley Exhibition.

The great liners which sailed across the Atlantic provided a nautical influence. Their streamlined wrap around windows and flat canopies are a feature of Modernism, while portholes are found in every style of building.

At the same time the principles of Art Deco designs were soon applied to housing, with Moorish arches and nautical windows appearing on the expanding suburban estates.

The Twenties saw the first owner occupier housing boom in Britain. People finally had the opportunity to express their individuality and aspirations through their homes, which resulted in some stunning new designs. The most fanciful of architects' dreams remained the province of those who could afford to commission a house to their own

1

specification. Mass market builders were faced with the same dilemma then as now, how to design and build homes within a realistic price range that would appeal to all prospective buyers. Their attempts can be seen in the suburbs of most towns.

Two schools of thought persisted among architects in Britain - those in the majority who essentially reworked traditional styles and the pioneering Modernists who produced plain functional designs.

Cautious buyers wanted traditional homes yet they wanted something new. The speculative builders' answer was usually a mixture of Mock Tudor and Modernism which could be secured for a deposit of £25 and a repayment of under a pound a week. The average yearly wage of a bank clerk in 1925 was £200.

The suburbs were essentially dormitory areas. The men went into town each day to work in banks, insurance companies and other 'white collar' jobs. Their wives remained at home caring for the house and children, with local parades of shops catering for everyday needs.

The Underground Railway was the focus of London's suburbs with many stations advertised as only a few minutes from the West End. In other towns the increasingly reliable omnibuses served the new communities.

The housebuilders of the Twenties and Thirties strove to create a distinct 'countryside in the town' atmosphere. The emphasis was on family life where home and hearth rivalled fresh air and healthy living for precedence. Countless families had gardens for the first time. Trees and grass verges lined many of the new suburban roads. Laburnum

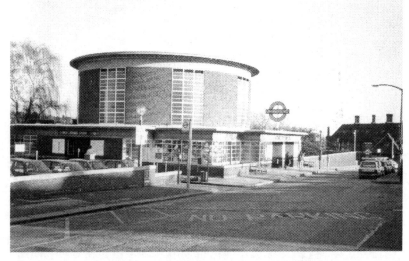

Arnos Grove London Underground station

Avenue, Woodfield Drive and similar names evoked a green and pleasant land in which to live.

Today these suburbs are encompassed by ever widening rings of newer housing and have lost their original country atmosphere. Millions of people live in them without realising that they could be in the historic house business in a few years time.

The Art Deco era, when some of the outstanding twentieth century buildings were erected, is now recognised as an historic period. More and more of the individually designed houses are being listed and at least one road on an estate of semi-detached houses has a preservation order on it. House builders are already re- working house designs of the Twenties and Thirties, which is concrete evidence that they are counted as historic.

The suburbs which characterised those years are an enduring symbol of the way Art Deco architecture affected the life of the ordinary 'man in the street.' They have taken their place as historic in their own right, and their owners are beginning to nurture the period aspect of their homes with the same pride as people who live in Victorian and Georgian houses.

Re-worked traditional styles and Modernist buildings both evolved during the time when Art Deco was at the height of fashion. The growing custom of including all the artefacts and architecture of the Twenties and Thirties under the Art Deco label is misleading, particularly where housing is concerned. Houses constructed in those years are more accurately described as 'houses built during the Art Deco period than Art Deco Houses.' But whatever they are called, few fail to reflect the Art Deco styles in some way.

Doors and Porches

The entrance, the focal point of houses throughout history, remained the principle feature of most homes built during the Art Deco period. The porch enticed visitors by drawing attention to the door, and secondly, afforded them shelter. It was never closed in to present a blind front until central heating became widespread in the 1960s. Since then many have been filled in with a second door which keeps cold air at bay but sends out signals of rejection to callers.

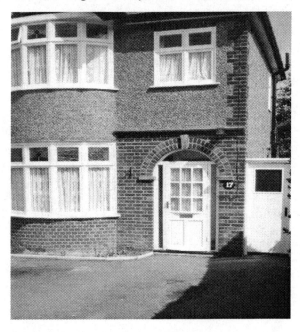

A filled-in porch sending out signals of rejection to callers

Doors of numerous styles were incorporated in Art Deco houses, but the contemporary emphasis on family life demanded a symbol of welcome, and here the Moorish influence prevailed.

For centuries the dark archways penetrating the white walls of Mediterranean houses have represented an invitation to enter. The Moorish arch is the basic shape of the majority of porches of the Art Deco era but it appears in many guises. They range from the simple semicircle, through to keyholes, with one, two, three, and occasionally

four, orders of brick arches around them, some running right down to the ground, others just over the curved section. Many are divided in two by a central keystone which dates back to Classical times. Some are outlined by brick or stone, or have a smooth rendered surround, to draw attention to them.

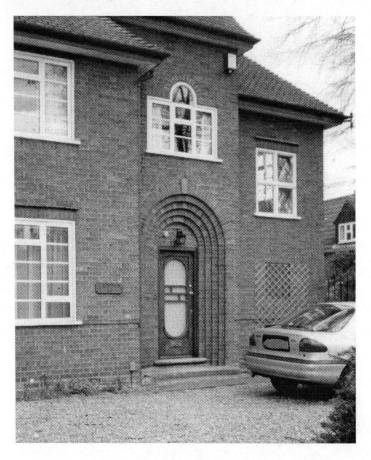

A rare five order doorway with a keystone surrounding a thoughtfully filled in porch.

The prize for the doorway with the most orders around it should probably go to one in Heath Side, Hampstead which has no less than eight rectangular arches enclosing a fully glazed metal door with a geometric design.

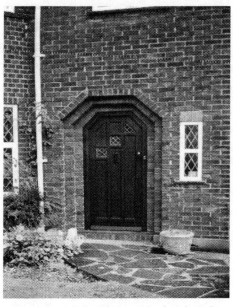

Assymmetrical doorwith a three order brickwork surround Cambridge

Keyhole shaped doorways emulate a style established in the Moorish buildings around the Mediterranean for hundreds of years. The colonnade surrounding the courtyards of such buildings inspired some architects to place the front door within a row of three or more arches. Examples of this are found in reworked traditional style brick houses while others breach the white rendered walls of Modernist homes.

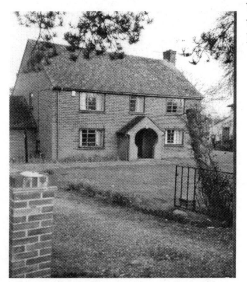

A Moorish keyhole in a gabled porch on this symmetrical house in Goring-on-Thames

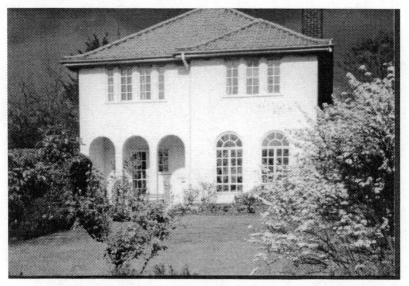

A Moorish colonnade, complementing the Venetian style windows, enhances the front entrance of this house at Harpenden, Herts

Deep porches with semi-circular tops or a full half circular arch enclose front doors in dozens of designs, but sometimes a shallow arch is purely decorative. One such arch on a bungalow at Southmoor, Oxfordshire, is a generous fifteen feet wide but only a few inches deep. It encompasses a symmetrical door and window arrangement set in gleaming white walls broken by red tiled window sills which complement the red roof tiles.

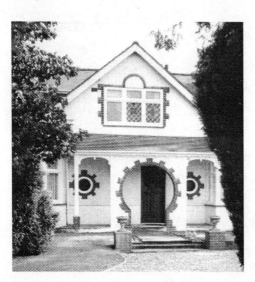

A keyhole porch in decorative brickwork with matching portholes Broham, Bedfordshire

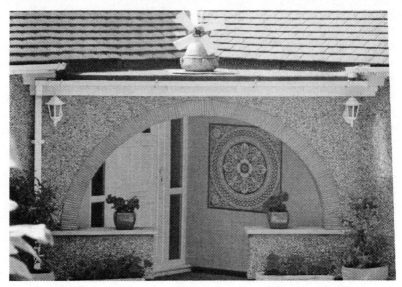

Spanish arch porch with a tiled wall with mosaic panel
Potters Bar

The contrasting styles of the times intermingle without restraint. A Moorish arch may well embrace a Tudor style solid wooden door with a lift up latch or strap hinges from the same era. Other solid wood doors are heavily studded in the manner of those in the Mediterranean where the larger the number of studs in the door, the more affluent the inhabitants.

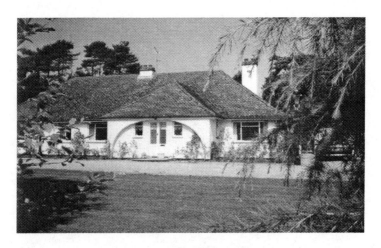

A shallow ornamental arch embracing symmetrical doors and windows,
Southmoor, Oxfordshire

*The heavy moulded porch reflects the fashion for Modernism
in complete contrast to the Mock Tudor beams. Hitchin, Herts*

Frequently a small window pierces a door to allow callers to be
inspected before admittance. Fashionable in Tudor and Jacobean times
and reappearing in the Twenties and Thirties, were tiny 'eyes' flanking
doors, in other words small windows on either side of the door.

An ogee shaped porch shelters a traditional wooden studded door Marston Gardens, Luton

Aztec stepped porch, sadly it has lost the original front door.

Note the decorative brickwork between the metal bathroom windows

London Road, Biggleswade

The reworking of Classical styles, which had already happened once during the Renaissance period, appears again on the Neo-Georgian buildings of the Art Deco years.

Doors flanked by pilasters or columns, and surmounted by pediments, embellish quite modest homes. But, whereas Georgian architects endeavoured to keep to the strict proportions and details of one style, motifs from the simple Ionic, the Doric and the more elaborate Corinthian orders are freely combined on Art Deco housing.

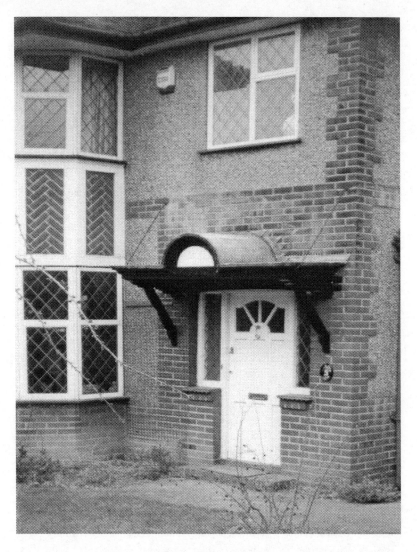

A porch canopy both suspended and braced to support the weight of the fan shaped ornamentation.

The house incorporates decorative brickwork and a touch of Mock Tudor Beechwood Avenue St Albans

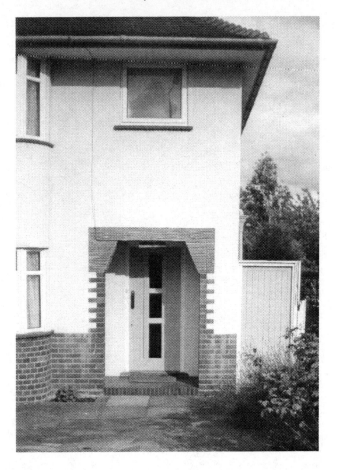

Edge on tiles form a semi-hexagonal lintel over this porch. Within is an original style door. Hitchin, Herts

Classical doors were often identified by their panels, which might number as many as ten. The style was revived during the 17th century and lingers on. By Victorian times the number of panels had dropped to four and architects favoured doors with two short panels at the bottom, a low handle and two long panels above.

The speculative builders of the Art Deco era often used panelled doors but preferred those with long panels below a shoulder height handle, topped by two short panels. In keeping with the bold bright colours of the Jazz Age the panels were painted in two colours and window frames received the same treatment. Painting the house was time consuming because the different colours were picked out on all the narrow beadings. The fashion for fresh air and country living meant

that green and cream was the most popular pairing, followed by red, or orange, and white.

Glass sometimes replaced the top panels. The windows round, oval, square, or formed from the small panels considered smart by the Arts and Crafts movement of the late Victorian days, usually had frosted glass or leaded lights. Stylised flowers enhanced millions of such lights, with country scenes, or galleons forever sailing across a bright blue sea in the houses of the better off. Some suburban estates have flotillas of boats sailing in perpetuity along entire roads.

The mock Regency look is rarely found in large numbers of houses but individual ones and pairs were built. Where doors are concerned, Regency is the most hard to distinguish from late Georgian types. But, where most Georgian doors had straight lintels, by Regency times arched tops had become popular. However, the Regency pagoda is unmistakable. Curved sheets of metal, supported by a frame, sheltered anything from a door to an entire verandah.

The Modernist school of architects, who mainly designed individual luxury houses, created doors from a variety of materials. They ranged from chromium-plated steel to polished wood and fully glazed metal

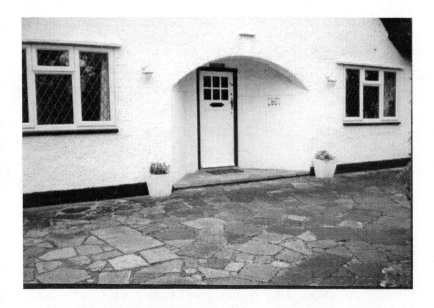

A recessed porch encompassing an Arts and Craft style front door
Letchworth

A fine Regency style door canopy
Heworth Road, York

frames. But the one thing they had in common was lack of decoration. Form and function were the essence of Modernism.

These ideas filtered down to suburban estates as doors comprising of four or five fully glazed panels of opaque glass, one above the other which were effectively a single sheet of glass and made for a very

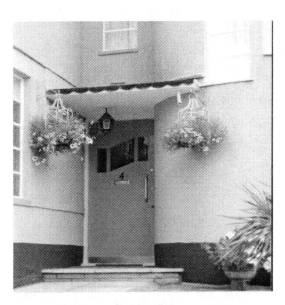

Cubist influence in this asymmetrical door
Valencia Road, Stanmore

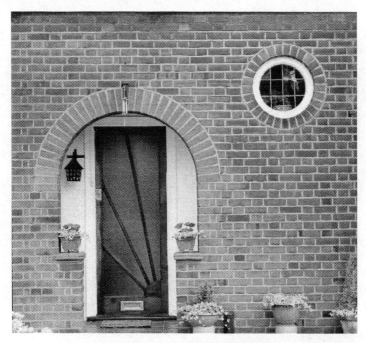

Sunburst door, once a common sight
Piggotshill Lane, Harpenden

light hall. But they were the bane of postmen and delivery boys, who found letterboxes at ground level back breaking.

The Modernists' keenness for glazed doors opening onto roof terraces, or from all the main rooms into the garden, resulted in houses with up to six doors opening to the outside. The speculative builders' version of this is seen as French doors leading to the garden or a door leading to a small balcony, often with a curved end. The balcony was of little practical use but did allow light into the house and easy access to fresh air.

Placing a pair of doors within an arch was also fashionable. Often they formed the entire front wall of the hall to allow fresh air to flow into the house in line with contemporary ideas about healthy living.

Fully circular 'moon' doorways are an Oriental feature reflecting the Japanese influence and are seldom seen on the creations of speculative builders.

A porch or a canopy to shelter the door was considered essential for every home. Canopies were often streamlined, with curved corners, smaller versions of those found on cinemas, which in turn imitated those on the great liners. But distant cultures are brought to mind when

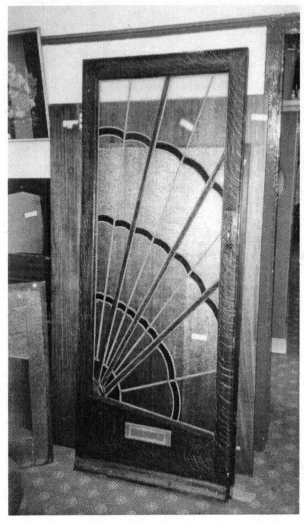

*A radiant
sunburst
awaiting a lucky
buyer in a
recycling depot*

Aztec chevrons are included in the door and window glazing under a canopy. Moulded concrete canopies appeared on Modernist houses. Simple versions were flat semi-circles above the front door. More elaborate were those with shaped corners and most unusual the asymmetrical designs such as those at Haywards Heath, which have a single flat concrete wall on one side curving over the entrance and stopping about six feet from the ground resulting in a hook, shaped finish.

Simply setting the door in a recess and adding a few inches of projecting canopy to produce a sheltered area formed some porches.

*These symmetrical doors with inlaid decoration are
pierced by a pair of hexagonal windows.*

The Dutch were leading architects of the day. Their contribution
has come down as curvilinear pediments giving height to porches,
which appear in brick with stone trim or have a smooth rendered finish.
Miniature versions of the main roof, be it hipped or gabled, with
flat boards on the underside, surmount other porches. Gabled porch

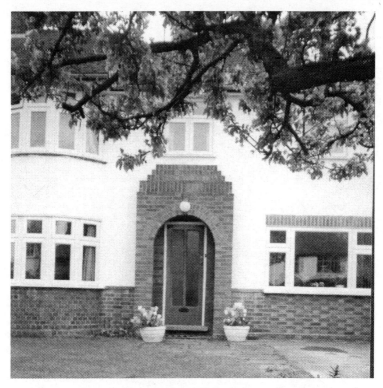

An Aztec stepped brick porch on this house in Queen Edith's Way Cambridge

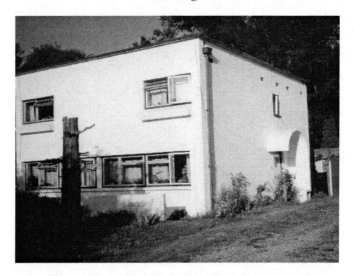

One sided concrete canopy around a door in Haywards Heath







Doors and Porches

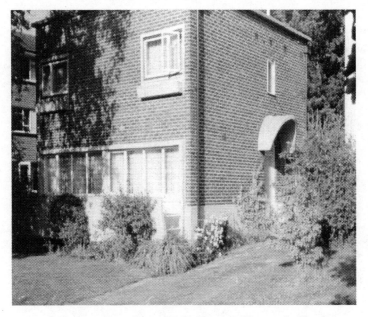

Concrete canopy around a door in Haywards Heath

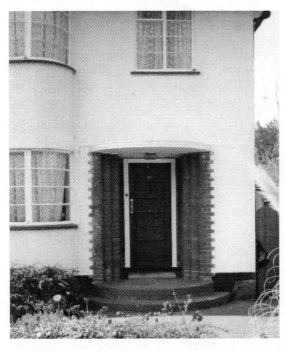

*Recessed doorway
with decorative brick
sides and small
projecting canopy.
Fan shape echoed by
the steps. Front door
is original.
Beech Road,
St Albans*

roofs were less popular although they lent themselves to being filled in at the sides thus providing extra protection from the elements, without obscuring the door.

The earlier custom of having halls adjoining in the centre of a pair of houses was abandoned in favour of having the living rooms

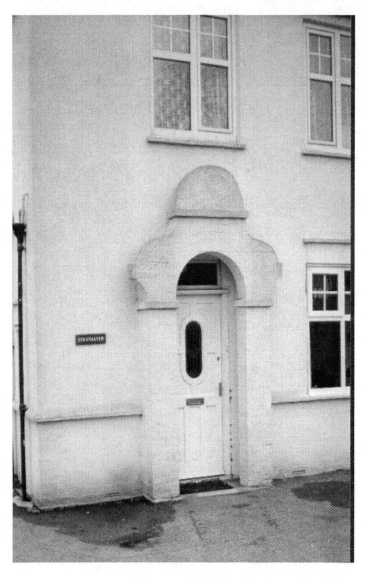

A Dutch influenced porch on a house in St Albans

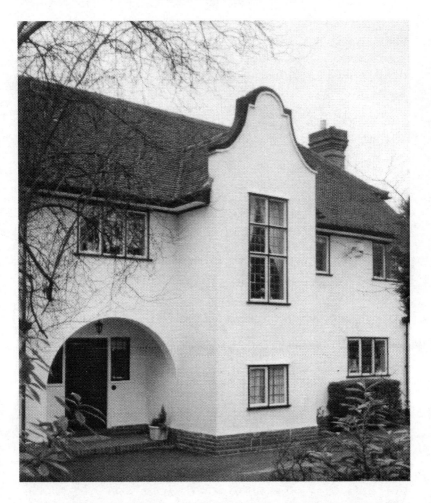

A Dutch gable juxtaposed with a Spanish arch on the house at Kingston

separating the entrances to enhance the privacy of the owners.

Many of the potential customers were buying a house for the first time. The builders of suburban estates, concerned only with attracting as many buyers as possible, mixed architectural details with abandon in order to appeal to all tastes. The mixture of contrasting styles is well illustrated by a doorway in Bloomfield Road, Harpenden. The small leaded window in the solid wooden door is patterned with Aztec

chevrons, and the small matching windows on either side are reminiscent of the 'eyes' of mediaeval times. An arch with four orders is emphasised by decorative brickwork which continues as a band drawing attention to the horizontal line. The arch is echoed by the fan shaped doorstep which is also in decorative brick and the path itself is the latest in crazy paving. But prospective home owners were not so concerned with the external appearance of the houses, for them the most important element of all was having their own front door.

A traditional solid door with leaded lights in an Aztec chevron design which is echoed by the side windows. The nautical canopy completes the symmetrical entrance. Sauncey Avenue, Harpenden, Herts

Windows

The easiest way to identify houses built during the Art Deco period is by the windows, which all reflect the fashion for fresh air and country living.

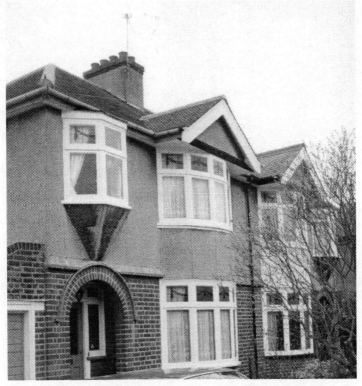

*To buy an ordinary bay windowed semi-detached house
was a popular ambition*

Bay windows are synonymous with the era. Their glazed arcs that were intended to catch the last vestiges of daylight incorporate a variety of designs. Where single panes of glass fill casements, to afford panoramic views, the fanlights might be leaded, and the glass is often coloured, thus obscuring the light. Most bay windows were semi-circular.

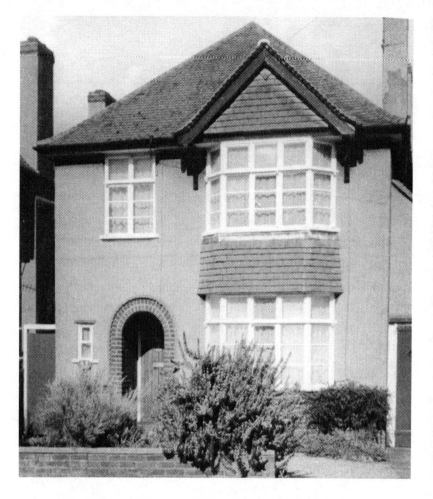

Semi-hexagonal bay windows in Harpenden, Hertfordshire

A few harked back to the semi-hexagonal ones, popular in Victorian times, which had only been made possible then because new, cheaper methods of producing glass meant that bigger sheets of it were available for common use in the 19th century. They had a large flat pane of glass in the centre and two small angled side windows.

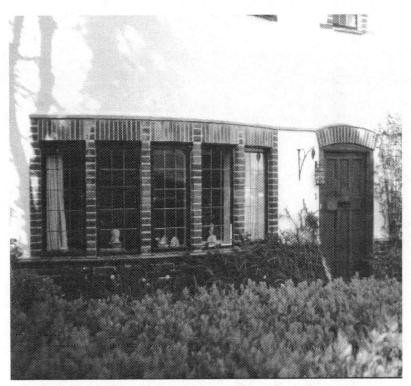

Decorative brickwork dividing the window into separate casements

Other bays consist of a series of separate windows divided by stone mullions, a style which dates back to mediaeval times. These were not so popular because the amount of light entering was considerably reduced. Inserting a bay window to 'modernise' an old cottage was usually a disaster. Examples are spread across the country from one in the High Street, at Goodwick, Dyfed, where two bay windows, which replaced upstairs sash windows completely unbalance the building, to a similar one in a sea front cottage at Southwold, Suffolk.

Architects re-working traditionally styled windows adapted them to maximise the light while keeping as close as possible to the original designs. Leaded lights, limited in size during the Tudor period by the space between timbers, expanded to fill much larger window frames.

Speculative builders found ingenious ways of fitting more glass into a house to trap every last beam of sunlight. Where space was at a premium such as in the boxroom of the average semi-detached house, two panes of glass were placed at right angles to each other in a

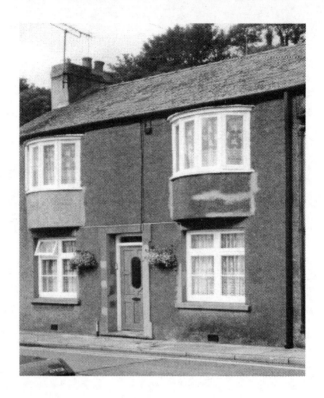

*Bay windows inserted in this old cottage destroy the
balance of the house completely. Goodwick, Dyfed*

window projecting oriel fashion; this allowed the maximum amount
of light to enter, but took up a minimum area of wall space.

The development of metal window frames by Francis Crittall at his
factory in Essex revolutionised windows after 1926.

Dozens of different shapes and sizes were possible using the new
mass production techniques.

Slimline glazing bars permitted maximum areas of glass. Double
height windows threw light onto staircases, which had previously been
one of the darkest areas of a house.

The production of curved metal frames made a tremendous
difference to the appearance of new houses. 'Suntrap windows' with
their sweeping curves were inserted by the thousand regardless of the
style of the rest of the house. They feature on mile after mile of semi-
detached houses along the A12 from London into Essex. Few towns
have none at all.

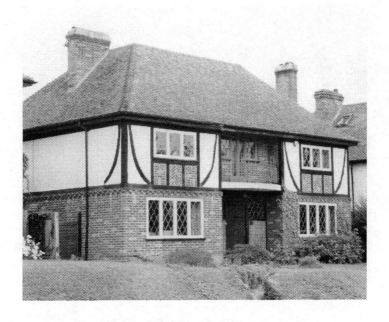

Well proportioned leaded lights in this Mock Tudor house in Harpenden

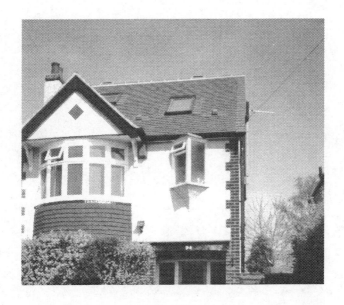

*Speculative builder's version of an oriel window, giving an
illusion of space in a small room and maximising light*

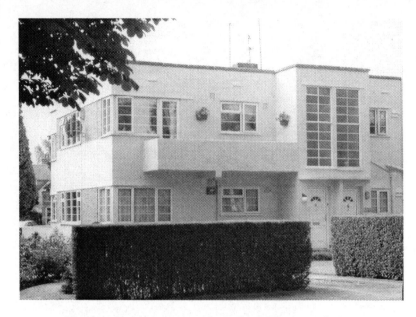

*Metal window frames came in multiple shapes and sizes,
allowing the maximum amount of light to enter*

*Double height windows in this house in Leeds Road, Harrogate. The
thickness of the rendering on the bricks is visible during resoration.*

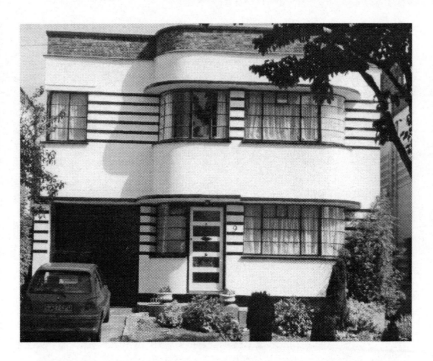

Suntrap windows with canopies and complementary corner windows

These metal window frames lent themselves to the nautical features of the great contemporary ships, which had captured the public imagination. Easily adapted to the streamlined shape of a ship's bridge they appeared in houses of all shapes and sizes. Once again the contrasting styles of the time were often confirmed by the inclusion of a tiny opening window leaded in Tudor fashion but patterned with Aztec chevrons.

'Triangular windows' were yet another device to allow light in. Unlike the pseudo oriel windows of the speculative builder these were metal frames moulded at right angles to each other and running the full height of the room. Not generally found in large numbers they are a major feature of the houses at Silver End, Essex, adjacent to the Crittall factory, and found in public buildings, such as the Hoover factory in North London.

Houses in Southway, Totteridge display contrast in the extreme by having neo-Georgian windows in the front and metal 'suntrap' windows at the back. Finding an internal decor to suit such rooms must remain a constant challenge.

Neo-Georgian houses were not popular with speculative builders because the style was favoured by local authorities for vast new estates built as part of slum clearance programmes. Those built for sale had

the small rectangular panes popular in the 18th century. But, like the local authority versions, they were set in casements with a horizontal emphasis, instead of in the form of vertical sash windows, which were fashionable in Georgian and Regency periods.

One feature transposed by architects from Regency houses to inter-war housing was the Venetian window. Basically rectangular, the central section culminated in a fan shape, which allowed more light into the room in line with contemporary thinking, and gave a touch of opulence to the facade. The grandest versions have a spider's web pattern on the fan glazing.

Corner windows were a way of ensuring that even north facing rooms received some sunlight for part of the day. Featured in Modernist houses, many are found complementing suntrap windows, but a few are to be seen in traditionally styled semi-detached dwellings. In the Stonegrove area of Edgware corner windows sit uncomfortably among heavy Mock Tudor beams.

Most houses with the Tudor touch have some leaded lights either rectangular or diamond shaped, even if only a single porthole on a modest dwelling. Clear leaded portholes are found down low lifting the gloom in understair cupboards, high up in attics and on every level in between. They vary from circular to square, diamond and hexagon shapes but are still basically portholes, and found singly, in pairs and occasionally as a foursome.

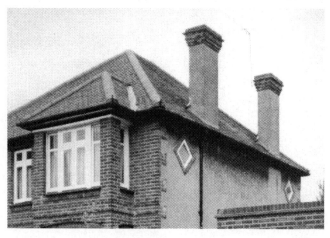

A pair of diamond shaped portholes flank a fine pair of chimneys in Gidea Park

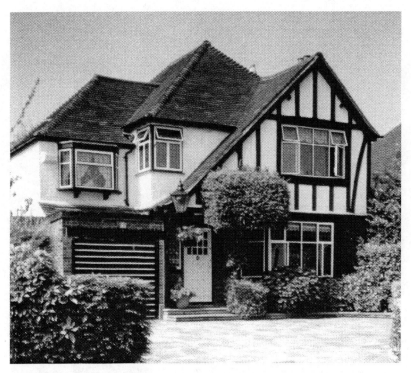

The corner window stamps Thirties on this Mock Tudor house at Edgware

Portholes are not to be confused with the round windows found in the 1920's version of Queen Anne houses, which usually have a square opening pane in the middle.

And like the other windows in a Queen Anne house, with their small rectangular panes, have a simple stone surround.

Other houses embody leads in the fanlights, landing windows or throughout. Homes with all the windows leaded were advertised as luxury dwellings. A few individual houses had alternate casements in diamond or rectangular leads after the style of the more exuberant 16th century glaziers. Close leading blocks out a significant amount of light but this was overcome by making the windows larger than they would have been in half-timbered mediaeval dwellings.

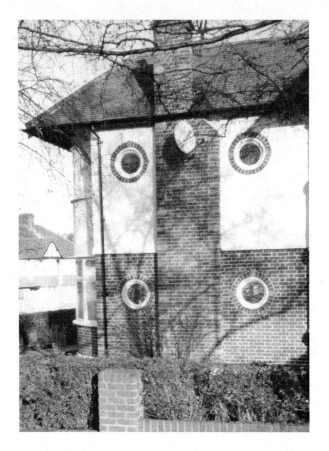

*Portholes either side of the chimney breast, with a
decorative brick surround. Arnos Grove, Middlesex*

The more elaborate windows have coloured lights in designs
revealing the contrasting styles and ideas of the times. Stained glass
windows were often used in the sides of houses, which were close
together, because they allowed light in while maintaining privacy.

Stylised flowers were the simplest form of pattern. A single rose
or tulip in red and green could be cheaply made from a mere half
dozen pieces of coloured glass.

They can be seen in row after row of average semi- detached houses,
either in the window of the front door, the hall, or in the fanlights of

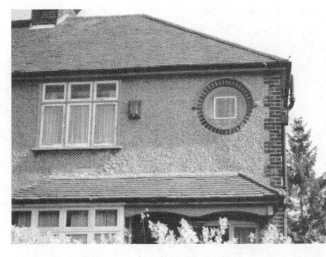

*A Queen
Anne window
illuminates a
bathroom*

the main rooms. Advertisements in homemaker magazines offered a
variety of designs costing around 7/6d (37.5p) per square foot.

The myriad styles of the day were found in the individual designs
for luxury houses, with nature predominating. Elaborate country
scenes, echoing a green and pleasant land, were popular.

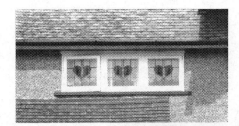

*Heart shaped motifs
abound in
Gerrard Road, Harrow*

*Stained glass
windows in a
symmetrical
house at
High Street,
Harrow Weald*

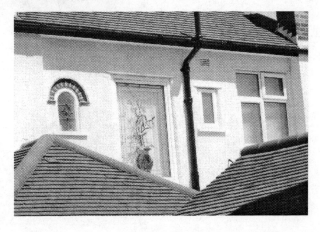

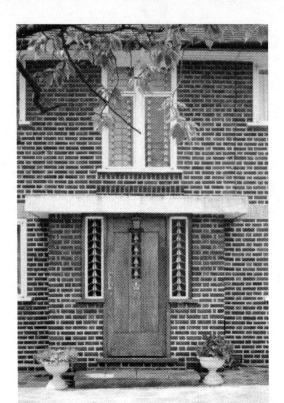

*Stained glass
landing window,
Chase Road,
Southgate*

*Glazed stairwell of a
Modernist house
in
Valencia Road,
Stanmore*

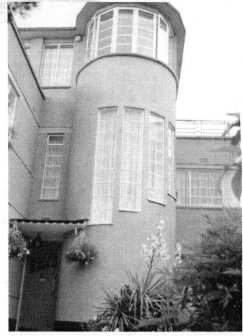

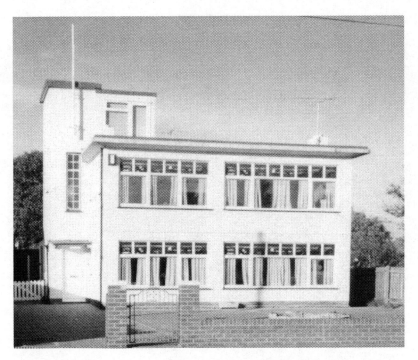

Modernist house has a colourful frieze running along the fanlights showing children playing in the countryside. Felixstowe, Suffolk

A house in Felixstowe has a riot of children playing in a green landscape, complete with windmills, running across the fanlights of four big square bays producing the effect of a coloured frieze.

Stained glass windows appeared inside houses, usually between the hall and the dining room. A coat of arms was often chosen for this, adding a prestigious touch to the building.

Nautical scenes were a feature of bathrooms with their watery connotations. Abstract designs in blues and greens suggested the sea, while yachts and liners permanently sailing on a wavy sea proliferated. A hall window in Harpenden welcomes callers with a lighthouse symbolising shelter and the nearness of home.

But galleons in full sailing rig were the nautical favourite for front doors. They harked back to the days of Britain's great maritime tradition. Yachts and ocean liners were inspired by contemporary transport.

The influence of Japanese art is most easily identified by a sun motif often manifesting itself as the rising sun bursting across all the fanlights of bay windows in a range of red, yellow and orange interspersed

*A new aspect
on a bow window
in
Old Bedford
Road, Luton*

with blue. Sun rays are found in glazed front doors and hall windows; examples still exist in Barclay Road, Leytonstone and Courtlands Drive, Watford, where there is also a fine sunburst in a landing window at

*The sun rising behind a
ship in a simple porthole.*

*Such designs could be
ordered from a pattern
book*

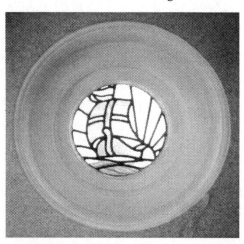

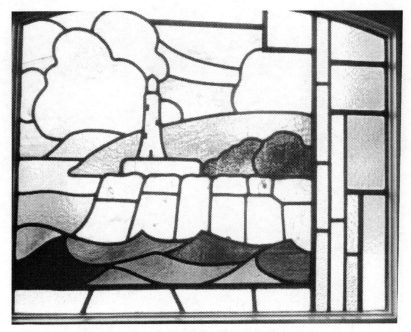

Landing window featuring a lighthouse

the corner of Woodland Drive together with a pair of hexagonal in portholes flanking a chimney breast.

More difficult to find is the moon motif, which is readily mistaken for a porthole where small windows are concerned. But 'moon' windows are not surrounded by decorative brickwork or glazed with leaded lights as portholes often are. A bathroom is the most likely place to find a small one. Large circular 'moon' windows are rare but the advent of metal window frames made them possible. The best chance of seeing one is in a Modernist house.

The developing machine age is seldom seen in stained glass but a colourful Art Deco house in St.Albans has a picture of a car speeding through the countryside in its garage window.

A less expensive way to give the appearance of leaded lights was a pattern of lead strips bonded to the glass usually as a border around each pane. This looks very effective on a group of houses in St.Albans where the builder has taken care to install different designs in neighbouring pairs.

Dormer windows, which were incorporated to produce a countrified look, were pretty but not practical. The amount of light coming in was restricted and the sloping ceilings were unpopular. Often a single

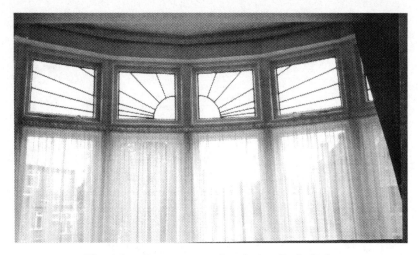

The rising sun was a popular design for fanlights.
Woodfield Drive, East Barnet, Herts

token window was inserted above the porch or at the side of the house
to give a rustic air.

The architects who favoured re-using centuries old designs drew
heavily on traditonal shapes and decoration but adapted them to fit
contemporary thinking. Modernist architects despaired as they saw
thousands of houses built with Modernist windows set among Mock

Pair of arched windows with sunburst design, flanking a chimney breast,
Ashridge Gardens, Southgate

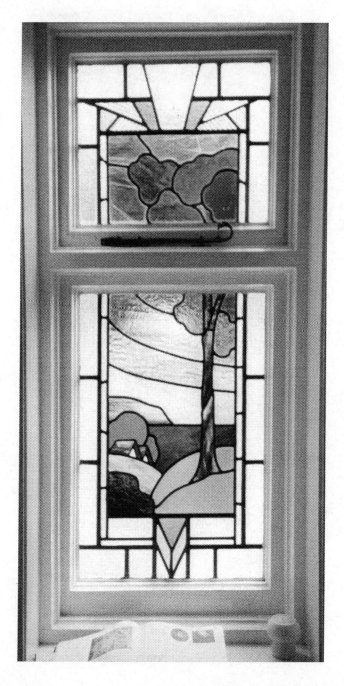

Country scene in a bathroom window with Aztec chevrons in the border

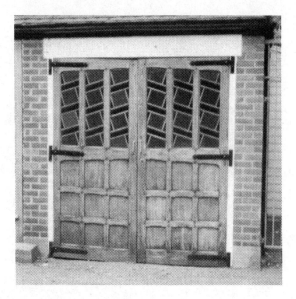

*Machine age repeat pattern in stained glass in
garage doors. Uxbridge Road, Harrow Weald*

Tudor beams or leaded lights in an otherwise up to date design of
house.

But whatever the style of windows favoured by architects and
builders they were united on one point. The occupants of all new homes
must 'see the light.'

Stained glass window in stairwell of flats at Cockfosters, Enfield

Mock Tudor

Mock Tudor was by far the most popular choice of home buyers during the Art Deco period. Its timber framed facades conjured up pictures of rural life in the traditional manner. Contemporary estate agents' literature pushed the Olde Worlde exterior, but emphasised the modern conveniences inside; because the small windows and low beams of Tudor days would not have been popular in the twentieth century. During the Art Deco period the half timbered houses familiar in many English villages inspired speculative builders.

Solid beams, matching door, leaded lights and decorative brickwork all impart a Mock Tudor touch to this doorway, Harpenden, Herts

*Poor brickwork is exposed where the timber has fallen
from this house in Southdown Road, Harpenden, Herts*

They reproduced the windows in the original style but much
enlarged to banish the gloom, and mock beams were added to many
otherwise nondescript semi-detached houses. Their attempts ranged
from one or two beams on a gable to give a veneer of tradition, to
timbers enhancing the entire upper storey, but rarely the whole house.
Their inclusion was a great success where marketing was concerned
although most were tacked on with no pretensions of providing
support for a house.

Tudor style is generally applied to any house incorporating wooden
beams although timber framed houses had been built for centuries,
not just during the Tudor period. Consequently the styles of timbering
represent designs from several centuries, not just Tudor times. So a
little of the history of timber framed buildings is encompassed in the
re-creations of the Twenties and Thirties.

The earliest timber framed structures usually had just enough posts
to support the building with large infill panels. These were
supplemented by arched braces or tension braces to spread some of
the load. Gradually builders began to think about the appearance and
attempted to produce regular sizes and shapes with the wood. These
simple lines are replicated on row after row of Art Deco houses usually
in the form of three or four beams on a gable.

*Barley twist chimneys top this exuberant pseudo Tudor
house in Colindale, Middlesex*

Mock Tudor beams are rarely part of the load bearing structure and few attempts were made to reproduce a house with an authentic Tudor look. Close studding is the style most often used in the Thirties on houses built for the more affluent buyers, but again the beams are rarely load bearing however realistic they appear.

Close studding, which meant placing vertical posts very near together, started in East Anglia, where there is a shortage of building stone, and had spread across England by the middle of the 15th century. It was expensive because the wood was costly and a large amount of labour was involved. The timber frames were infilled with wattle and daub, lathes and plaster, or any local stone until bricks, which had fallen from favour after the Romans left, became fashionable again in the 15th century.

Houses constructed entirely of bricks began to appear but many owners simply used them to replace the infill between the timbers of their homes. Difficulties arose with infilling close studding, and a great deal of ingenuity was needed to fit bricks in, which resulted in a variety

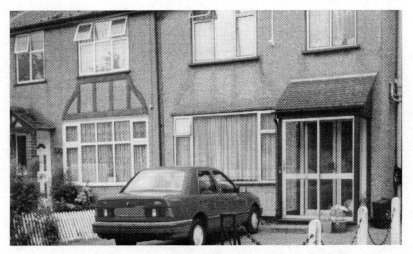

The tacked on timbers have been removed from this house revealing how thin they were. Batchwood Drive, St Albans

of patterns. Numerous Art Deco versions of Mock Tudor have bricks laid in this way, the most popular being herringbone.

Some houses incorporate several different designs; one space infilled with herringbone while the next has a standard brick pattern and even an area of edge on tiles in the centre. Even minimal attempts at Mock Tudor had a modicum of decorative brick infill.

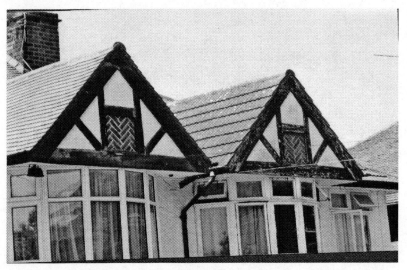

Mock Tudor gables with a token section of decorative brickwork, above bay windows, Hampden Way, Southgate

A long row of houses in Hampden Way, Southgate flaunted timbers on gables over the bay windows. They were arranged to include a tiny square of brickwork in the centre. Most of them have been painted over now, or lost some of the timber. Only one pair remains as they were built.

Despite its problems half timbering remained in favour with wealthy people, even after Tudor times, because it reflected their status. The later and most elaborate timber framed buildings incorporated curved wooden beams in symmetrical patterns. Heavily decorated these timbers often materialised as elaborate circular motifs within square framing. This style was particularly popular in the West Midlands where Little Moreton Hall, Cheshire is perhaps the best-known example.

One L shaped replica, on the corner of Devereux Drive, Watford, makes a fair attempt to look genuine with a jettied upper storey, leaded lights, diagonally set pairs of chimneys and a steep gable complete with decorated barge boards but does not quite succeed. The beams are a little too straight and the corners a little too square.

More successful 'The Tudor House' in St.Albans has realistic mediaeval braces and heavy timbering. Under the gable, the architect has used decorative bargeboards that were a feature of high status Tudor houses. The pattern includes the Tudor rose so beloved of King Henry the Eighth. A lych gate, and leaded lights all add realism.

Next door vertical beams widening out at each end enhance the area between the upper and lower square bay windows. This gives

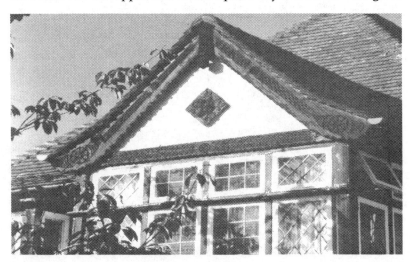

*Decorative barge boards on a Mock Tudor house in
Harpenden Road, St Albans*

the impression of the jowled joists seen on buildings as early as the 13th century. The extra width at the end allowing more room for the carpenter to fashion a joint which might need to include more than two pieces of timber.

In nearby Batchwood Drive a pair of semi-detached houses is pebble dashed in contemporary style but with wood tacked on top in imitation of beams, between the upper and lower windows. The removal of the wood from one house during modernisation shows just how thin it is and has completely destroyed the symmetry of the pair.

Various patterns, which bore no relation to a framework, appeared such as a chequerboard design on a house in Beaumont Road, St.Albans.

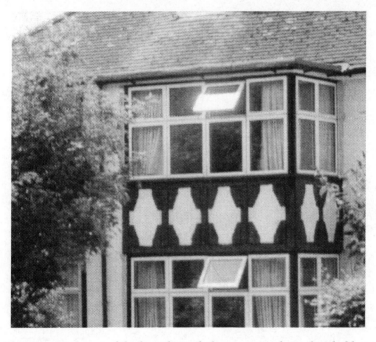

Design reminiscent of the heavily jowled posts in mediaeval aisled barns.
Harpenden Road, St Albans

Another feature, which came to the fore in the 16th century, was a jettied upper floor formed by simply allowing the ceiling joists to overlap the frame beyond the wall of the lower floor. Sometimes the jetty formed the roof of a projecting window. This feature was commonly copied in the 1930s, as was the fully rendered jetty with was no pretence of any timber supports.

The timbers would have been left in a natural state on original houses. The infill remained the colour it had dried or was painted with a clay or lime wash made from local materials. Woodland Drive, Watford has one such house that has bare timbers on the gable and the garage doors; set alongside bay windows, complemented by an arched porch in decorative brick and pebble dashed panels it gives a rather strange effect.

A builder in Arnos Grove erected a whole row of houses with timbers tacked on and around the bay windows, then he pebble dashed the

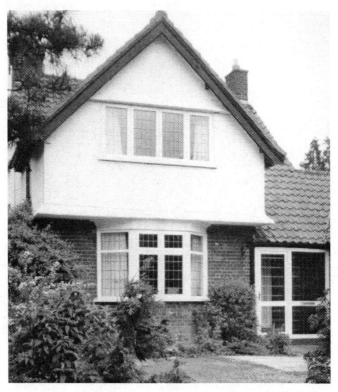

A jettied upper storey forming the ceiling above a bay window,
Letchworth

Jettied sections of a balcony running along a row of shops at Temple Fortune, North London overshadow the pavement below. The whole structure is made of massive beams and worthy of Romeo and Juliet. In contrast another at Mill Hill is of lighter timbers and tucked under the eaves of a downswept roof. It fronts a blank wall of the house with no window, no door and no access.

Massive beamed balcony above shops at Temple Fortune, North London

Most pseudo Tudor homes had the timbers painted black and the infill white, following a fashion started by the Victorians.

whole facade and painted the timbers white which looks very odd but the residents present a united front by keeping to the same colouring.

Tudor style in white, Dawlish Avenue, Arnos Grove

Even flats were subjected to the Tudor treatment. A four-storey block near the former Hendon Aerodrome, bearing a plaque with the legend Amy Johnson Aviator lived here, is a patchwork of red brickwork and black and white sections. But they are just a token of Tudor style and do not look remotely like a Mediaeval structure.

While builders were plastering their properties with tacked on timbers other Art Deco influences crept in.

The Japanese sunbursts appear on Mock Tudor gables, over pairs of bay windows, as far apart as Ipswich and Bristol. The owner of a semi-detached house with a shared gable, in Gidea Park, has 'updated'

Mock Tudor beams set in a Japanese rising sun design on the gables of a pair of semi-detached houses Dunstable, Bedfordshire

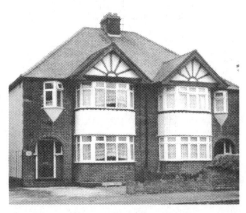

his property by removing his half of the gable's sunburst, thus ruining the appearance of both houses.

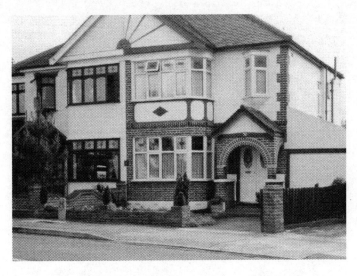

Semi-detached houses need treating as a whole or disaster results. Gidea Park

In St.Albans an impressive sunburst, of massive timbers, surmounts an arched beam that forms a porch in Moorish style; and next to it triangular bracing on the front of the house is combined with rustic cedar cladding on the main gable.

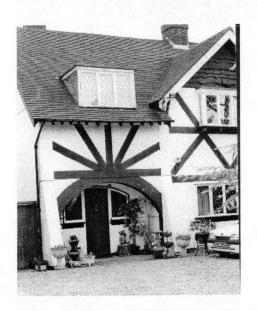

Stunning Japanese sunburst porch

Watling Street, St. Albans

A Wealden style house in Harpenden has huge arched beams, reputed to come from a ship, under the main windows. Questions as to which part of a ship they came from or how they came to be removed remain.

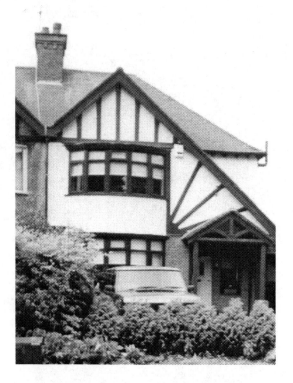

Mock Tudor beams arranged in a rising sun
quadrant on a house in New Bedford Road, Luton

On a pair of semi-detached chalets in Luton's New Bedford Road the beams are arranged as a quadrant above the porch giving the impression of a divided sunburst.

Aztec chevrons so beloved of the Mexican Indians commonly featured in the leaded lights of Mock Tudor homes; but they were not incorporated in the timbers.

Nautical themes were another strong influence. Apart from the 16th century galleons adorning the glass in front doors, many houses were rumoured to be built from ships' timbers.

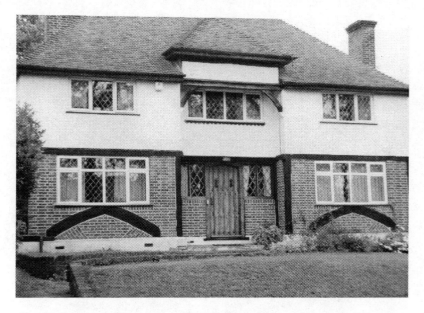

Nautical 'ships' timber set in a Wealden style house, with some decorative brickwork. Sun Lane, Harpenden, Herts

The Wealden style originated in Kent, and reflects the prosperity of the community between London and the Continent. Its distinguishing features are a central hall of double height and jettied end chambers, all under a single roof. And often flying braces linked the end sections to the eaves of the centre section. 'Stockbroker Tudor' is often built in Wealden style but it does not adapt well to the smaller houses of suburban estates.

The residents of Northolt can set their watches by a tall timber framed clock outside the station. Infilled with herringbone-patterned bricks, the frame supports four faces with Roman numerals, and a weather vane tops the pitched tiled roof adding to the Olde Tyme appearance. The clock stands on a typical suburban green in front of a parade of local shops, and with mature trees around, it still imparts a rural air.

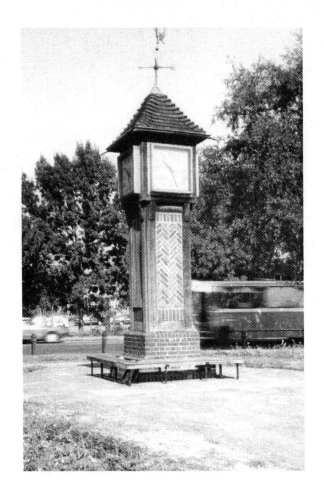

Striking example of Mock Tudor

Art Deco public clock
outside Northolt Station
forms a focal point for the local community

Decorative Brickwork

Decorative brickwork was the easiest way to distinguish one pair of houses from the next on estates of otherwise identical houses. The difference could be as little as a single tile to large areas of the facade.

Patterning between upper and lower windows was a popular way to give a house an individual identity. Four or five tiles could be arranged in various ways on each pair of a whole row of houses. Semi-detached houses were treated as one building in terms of identity with the symmetry of the mirror image effect preventing each half from looking exactly the same.

Centuries ago early housebuilders did not worry unduly about the appearance, using stone quoins merely to support the corners of houses built of random stone. As the ornamental possibilities of the quoins became more appreciated the original purpose was superseded as they began to be used to emphasis the shape of a house.

Decorative brick quoins offered scope for Art Deco architects to put their own stamp upon a house. Geometric patterns of every shape materialised, forming decorative frames around houses. Even modest

Decorative brickwork, Gidea Park, Essex

houses could include quoins of different coloured bricks, or have them set in rendering, without significant extra cost.

In the Repton Gardens area of Gidea Park, decorative brickwork abounds. One house not only has zig-zag quoins but also a hipped gable with herringbone brickwork surrounding a brick arch, which in turn surrounds an arrow slit. Other houses nearby have decorative

Decorative brickwork on
Luton houses

brickwork supporting rendered jetties, and rarely seen brick buttresses supposedly propping up walls.

Yet more have decorative plasterwork. Decorative triangles span the single gable above the bay windows of one pair of houses. The centre of the triangle is filled with coloured spots which are repeated in decorative diamonds between the upper and lower bays.

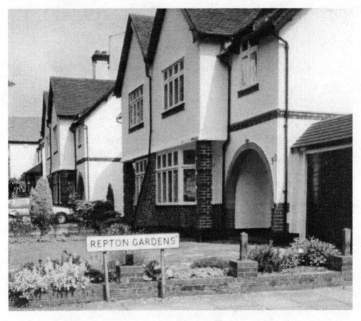

A brick buttress fails to give this house an ancient appearance

Another unusual house at Welwyn, Hertfordshire, has brick quoins in a triangular pattern complemented by brick panels below the windows; and a tiled arch, infilled with decorative bricks, above one window, is rivalled only by a patterned brick porthole in the rendered gable.

Such panels were doubly inspired. The first by traditional Mediterranean architecture. On the edge of Sahara, in the oasis of Tozeur, where all the great treks across the desert began, tourists can see a wealth of this type of brickwork which was put up in the 16th century. The designs are formed by some bricks being set further forward than others which produces a kaleidoscope of dark shadows as the sun moves across the sky.

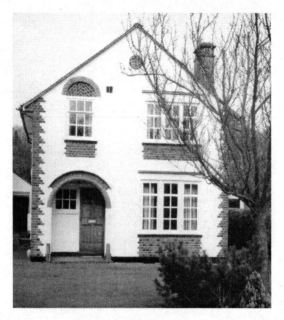

Decorative brickwork features include arches, panels,
quoins, chimney top, edge on tiles and even a porthole

Speculative builders simplified these images as panels with bricks set in geometric patterns. These are easily confused with the second influence which was the intricate designs of brickwork used to infill the posts of timber framed houses.

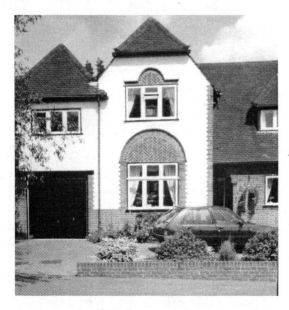

Arch motif in
panels filled with
Mock Tudor
decorative brick
infilling

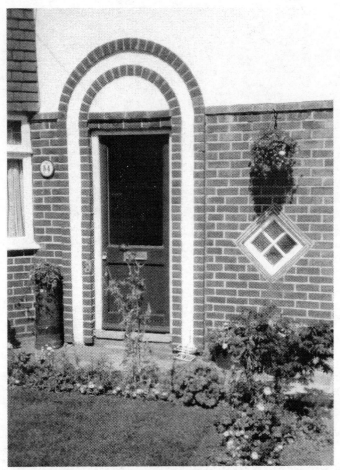

Eye catching decorative brick arches with diamond shaped porthole, St Albans, Hertfordshire

When bricks, neglected since Roman times, came back into vogue in Tudor times, buildings incorporated decorative patterns in the brickwork. Diamond shapes in different coloured bricks, called 'diaper brickwork' were common. Ornamental brickwork surrounded openings and ran along parapets. As already mentioned brick infilling between beams was often intricately patterned in order to fit into the available space. Brick arches, again reflecting the Mediterranean influence, are found on houses of all kinds.

The simplest form is an arch of single bricks surrounding a porch or set in either a brick or rendered wall, while the intermittent brick outline

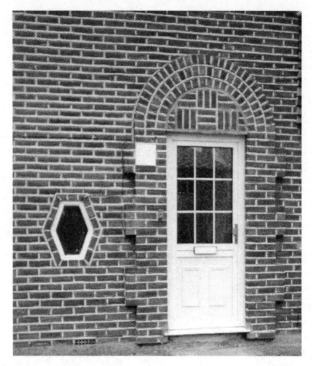

Understair portholes in all shapes feature together with decorative doorways to ensure that no two pairs of houses are identical. St Albans

is slightly more decorative. Arches infilled with bricks in geometric patterns make a bolder statement and are often sited above a window. The brick walls of balconies were relieved by openwork designs in geometric shapes and occasionally half sections of clay pipe were used to form attractive arched patterns.

Typical Art Deco influences show up in many ways. A pair of houses at Hounslow Heath could be described as the usual mixture of details with bay windows, divided by hanging tiles and small windows flanking the door. But within the gable a touch of Spain appears as a small decorative brick arch painted to match the barge boards. An individual architect might use decorative brickwork in a particular way that immediately marks the house as designed by him. This is seen in Harpenden where many houses built by Jarvis feature a brick edging around every window and matching brickwork between each casement.

A St Albans builder used decorative brickwork in a variety of shapes to support oriel windows against rendered walls. He also placed

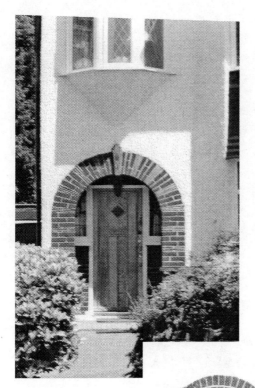

*Shaped bricks and
tiles make up this
Spanish arch porch
embracing a solid
oak door with a
diamond porthole*

*Decorative
brickwork
doorway with
understairs
porthole.
Beaumont Road,
St Albans*

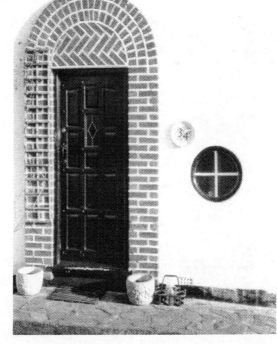

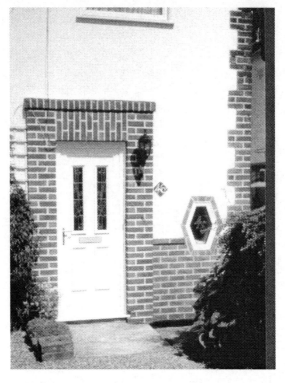

Decorative brickwork doorway with hexagonal
understairs porthole, St Albans

rendered fan shapes above garage doors and trimmed the top edge
with a row of bricks.

Frank Lloyd Wright, an American exponent of Art Deco, to give
horizonal emphasis to his designs, used brick banding. Created at the

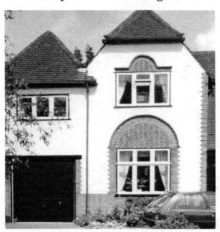

Fan
shaped
decorative
brick
panels.
Harpenden

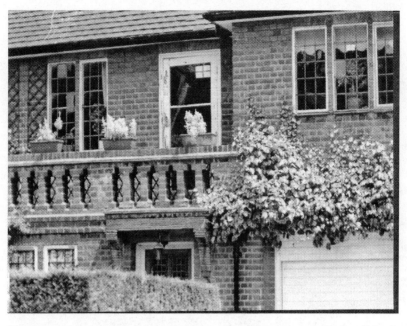

Decorative brickwork balcony. Thornton Road, Hampstead Garden Suburb

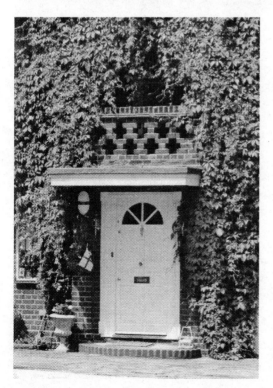

Decorative brick balcony. Meadway, Hampstead Garden Suburb

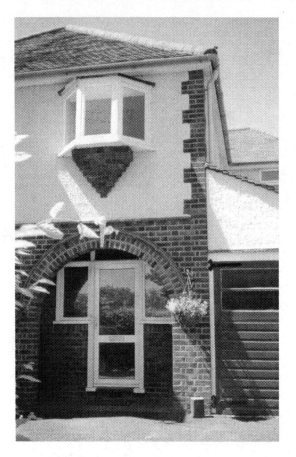

*Triangular shaped decorative brickwork
supporting an oriel window. St Albans*

dawn of the machine age, the banding emulated speed. The long
courses of contrasting brick echoed the lines that were painted on the
streamlined livery of record breaking railway engines to stress their
power.

St.Albans has two rendered houses each with eight bands of brick,
interrupted by the upper windows, running across the front of the
house. A few miles away near King's Langley, the symmetry of a
double fronted bungalow is emphasised by horizontal brick banding
which is an extension of the decorative brickwork around the porch.
In the Southgate area of London, plenty of houses have this distinctive
banding. The most spectacular are in Abbotshall Avenue, where pastel

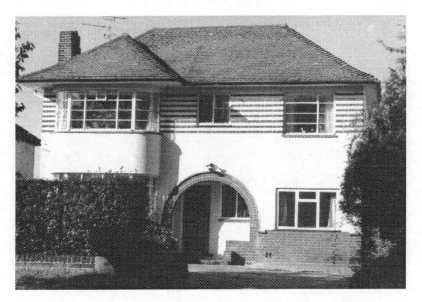

Decorative banding, emphasising the horizontal line, after the style of Frank Lloyd Wright

coloured exteriors are contrasted with blue, black and orange stripes and some surmounted by a yellow brick parapet.

Brick banding is not to be confused with re-worked Byzantine style, although it is similar. Byzantine style buildings are in brick incorporating stone bands with much more space between them than the machine age version. It takes its place among the revival of other classical styles, which had already been resurrected during the Renaissance period, but some Art Deco architects reworked them once again.

A Classical pediment in brick above a block of flats in Grange Road, St.Albans was constructed entirely for appearance's sake, serving no structural purpose. But with a flat roof behind it, no doubt it served to shelter those keen enough to stretch out in the sun on a fine day.

The Classical influence appears as dentillated brickwork, where a series of alternate bricks project further than the others in the same course. Used as a decorative feature it is found over porches, between the upper and lower floors and as a frieze at roof level.

The nautical influence is hard to find in brickwork but one enterprising Watford builder created the ultimate in textured rendering by covering a house in Woodland Drive with a wavy pattern. A similar wavy pattern runs along the lintels of some Modernist houses in

Triangular pediment forms a focal point for the symmetrical facade of these flats. St Albans.

Hampstead Garden Suburb, linking the curved suntrap windows with the square corner windows and the canopy porch.

Equally difficult to find are Japanese sunbursts in brickwork. But the moon symbol of Japan is represented by circular areas of brickwork in rendered walls such as one on a bungalow at Dunstable. Also in Dunstable a curious way of using bricks is seen on pairs of semi-detached houses in the Meadway. The projecting central part of the houses is curved at the ends nearest the front doors as though suntrap

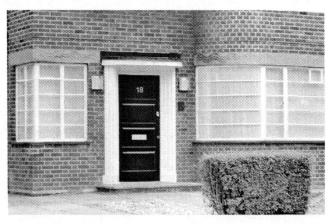

Nautical influence above suntrap and corner windows. Rowan Way, Hampstead Garden Suburb

windows were going to be fitted. But the builder appears to have changed his mind and has filled the curved areas with bricks and glazed just the flat part.

One of the oddest ways of using decorative bricks is in imitation of 'repairs' to simulate an old country cottage. Bricks in ones, twos and small groups are set at random in rendered walls to produce this effect.

Monkfrith Way, Southgate has a good example, there's another, in Luton's Old Bedford Road, and they appear like a rash on bungalows in the main road of Polegate, Sussex. In Leeds Road, Harrogate, the same effect is achieved with dressed stone blocks. A few doors away similar stone blocks surround the porch in an asymmetrical pattern.

Crow steps were also popular for outlining the tops of gables, especially in East Anglia, no doubt because the original ones came from the Low Countries. With a profile like the side view of a flight of steps they were ideal places for birds to perch and it is easy to see how they got the name. Reworked versions appearing over porches and along roof lines vary from just one or two steps to a whole flight. They have been used as a decorative brickwork design on pairs of houses in Dunstable. The houses are mainly white with brick quoins, but where one pair has a stepped pattern around the porch the next has the same pattern in reverse. All are linked by a brick band which takes a big

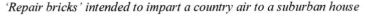

'Repair bricks' intended to impart a country air to a suburban house

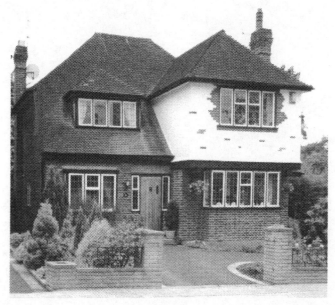

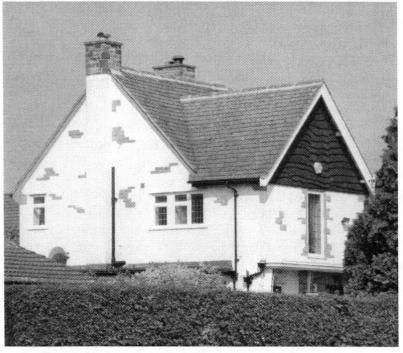

'Repair' bricks and rustic cladding are meant to give this house a cottagey look

step in the centre where a flamboyant brick cone reaches from the ground to the first floor.

Random stone blocks surmount this chimney in Leeds Road, Harrogate

A single tile bearing a Clarice Cliff style country scene with the house number superimposed on it is a reminder of the brilliant colours of the time which, where brickwork was concerned, mainly filtered down to the suburbs as coloured stone blocks inserted to attract attention. Several houses in King Harry Lane, St.Albans, have the windows outlined in alternating green and rust blocks, which is very striking.

Red bricks were favoured for their warm colour and reflection of Tudor times but decorative patterns, rendering, pebble-dash or hanging tiles invariably broke up large areas of brickwork on Art Deco homes.

Decorative tiles can be seen on thousands of houses. They range from a single tile to areas of hanging tiles between bay windows and completely covering the walls of a house. Many are highly coloured and set in attractive patterns relating to the traditional tiles of the Mediterranean area.

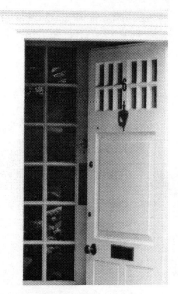

Art Deco tile bearing the house number. Lytton Close, Hampstead Garden Suburb

Plain hanging tiles are a reminder of earlier centuries when tiles were nailed on lathes fixed to the posts of timber-framed houses, to encourage rainwater to run off. Tiles set on edge above windows had a similar purpose, as they were originally intended to divert water running down the walls away from the windows. The earliest were set in straight lines but later builders developed a bow shape as more efficient. Art Deco builders used this feature to good effect. Bows were

made of brick or tiles set in plain or rendered walls and infilled with thin tiles or bricks. Three or four tiles set on edge were often used to replace a single brick or occasionally a whole row simply to vary the texture of the brickwork. A house in Burwell, Cambridgeshire has an H shape on its side in a white rendered wall purely for decoration. A few tiles were often found where the wall meets the roof but the most unusual concept must surely be as roof braces imitating the timber braces traditionally used to support heavy roofs.

Bricks moulded in individual designs were rare because they were expensive, but they can be found. A house in Haworth Road, York is built of moulded bricks, which are much thinner than standard ones. Symmetry, stained glass bay windows, hanging tiles and a decorative brick chimney label it as pure Art Deco. And moulded bricks are a feature of a new supermarket in Ripon which could revive the fashion for them. Whatever style was chosen the majority of new owners believed that there was no better investment than bricks and mortar.

Modernism

Modernism is the most conspicuous of the Twenties and Thirties architectural styles. Its flat roofed geometric outlines, with smooth white walls, broken by large areas of glass, are plainly visible. The Modernist school of architects shunned ornament. Form and function were their bywords which resulted in some very stark offerings. Some architects pressed even the roof into service as a recreation area. A high parapet discernable by the level of drainage holes, and often a stair tower, reveals such a roof. Other architects contented themselves with roof terraces at a lower level usually reached by doors from the upper floor.

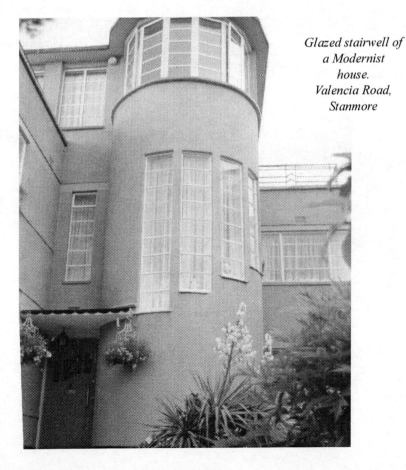

Glazed stairwell of a Modernist house. Valencia Road, Stanmore

Most Modernist houses were designed by architects. Comparatively few were built north of Watford. Clusters of a dozen or so, optimistically termed 'sun houses,' are found but speculative builders who ventured into flat roof enterprises soon found that sales were slow. Prospective owners, especially first time buyers, baulked at purchasing property in such an extreme style. Would it prove a good investment? Would it be difficult to sell?

Such uncertainties meant that these sun orientated homes never really caught on. Most people preferred a more conventional dwelling so the ever resourceful builders combined aspects of Modernism and 'Olde English Charm' on the outside, with modern conveniences inside. Consequently millions of houses incorporate Modernist features.

Suntrap windows are glaringly obvious even when surmounted by a pitched roof. Found in significant numbers as far north as Yorkshire they are usually a feature of houses which are otherwise traditional in design; but the number decreases sharply by time the towns of the northeast are reached.

Sun trap windows, decorative brickwork and flat ships' canopy.
Gidea Park

In the south mile after mile of them sparkle either side of the, then, new arterial roads - such as London to Southend - which were spreading rapidly as the car owning population expanded.

A second feature is white walls whether they are concrete or rendered bricks, but usually under a time honoured pitched roof. Often a few tiles to impart a traditional touch break the surface.

A third clue is provided by glazed doors which add light to interiors but have opaque glass for privacy.

A broad spectrum of Modernist styles can be seen at Silver End, where Francis Crittall built about five hundred houses for the employees in his metal window frames factory.

Three individually designed luxury houses were built for the company's executives. One, Wolverton, a symmetrical cream rendered house, has only a single upstairs window in the front, which is a full height triangular shape opening onto a balcony. This window illuminates the landing which runs right across the front. Four bedrooms lead off it, all commanding a rear facing view across open country. The choice for the supervisory staff was standard semi-detached brick dwellings, with pitched roofs, similar to those on estates built for sale in the London suburbs.

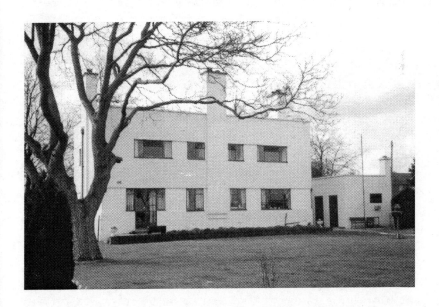

All four bedroms face the rear garden of this symmetrical house at
Boars Tye Road, Silver End, Essex.
Originally built by Frank Crittal for his company accountant.

Then, striking a second blow for Modernism, rows of flat roofed terraced homes were erected for the production workers. White rendered, with green window frames, among a network of the original privet hedges, they still present a vision in green and white. Full height triangular windows on the upper floor echo those of the executive homes and contrast sharply with the county council's neo-Georgian primary school.

Modernism lent itself to the coast where sun was always optimistically expected. Half a dozen flat roofed houses on the low cliffs at Old Felixstowe were built with balconies and roof terraces to catch the morning sun. Unfortunately they also caught the east wind and several have been enclosed in glass, but the original designs are still discernible.

Further down the coast, Frinton-on Sea, was once advertised as Britain's 'first Modernist seaside town.' The layout of Frinton Park Estate was designed by Oliver Hill who is best known for his Midland Hotel, Morecambe Bay which displayed its curving lines on television as the setting for a film featuring Agatha Christie's Belgian detective Hercule Poirot. The Estate was intended to be the first Modernist resort in Britain, with twelve thousand houses focusing on a new town hall, a hotel, three churches and a station. The town did not materialise due to financial and technical problems, but enough was built to form the largest group of Modernist houses in Britain.

Oliver Hill designed over a dozen of the surviving houses of which The Round House is the most eye catching. Originally serving as the estate office it is the only listed building in Frinton Park. Shaped like two drums, one on top of the other, it looks rather like a wedding cake. The smaller upper storey has windows right around it and the wall of the lower storey is broken to form a verandah in front of the main entrance. The inside is a labyrinth of small rooms radiating from the centre with barely a straight wall between them. It was offered for sale at £360,000 in 2002.

No entrance is visible on a perfectly symmetrical house in Mildenhall, Suffolk. Built from red brick it is double fronted with bay windows, and a flat roof. The house steps in on either side at the depth of one room and the door is hidden in one of the angles, a ploy often used by Frank Lloyd Wright to preserve the horizontal emphasis.

On the other side of Suffolk, a house in Halesworth Road, Southwold, is an example of a Modernist house sited between traditionally styled neighbouring properties, with no features to link them. Its flat roofed, cream painted, exterior includes a double height window on the staircase. To take advantage of the sun, the main

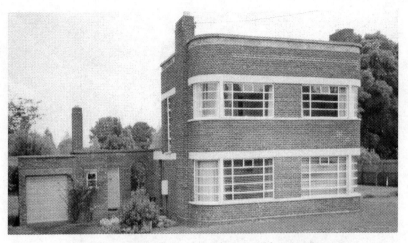

Frank Lloyd Wright style with no visible entrance.
The deep brick pediment indicates a roof terrace. The main
door is behind the chimney stack. Mildenhall, Suffolk

windows face south, but true to form, the windows of two north facing rooms turn ninety degrees around the corners to trap every possible vestige of sunlight.

The nautical influence was strong in Modernism. The great Atlantic liners of the Twenties and Thirties were floating exhibitions of high style, and architects copied many of their structural features. Portholes featured in every school of Art Deco architecture. Less common was the flat canopy reminiscent of those protecting passengers on the decks of liners. Architects used them to cover porches, on rooftops and balconies, and more rarely, to shade windows. A popular alternative to the arched porch they come as simple rectangles, or with curved front edges evoking images of a ship's bridge. One such canopy is found above some shops in Chipping Norton. The golden Cotswold limestone building matches the rest of the traditionally styled town centre but the flats have metal window frames and unbelievable over the first floor windows a stone canopy which could have come straight off a liner.

A closely related influence was the Streamline style. Its great flowing curves were more suited to large structures such as cinemas but the essence of it was watered down to appear on domestic buildings.

Nine houses in Abbotshall Avenue, Arnos Grove, exhibit horizontal stripes that rival all others in England. The houses are similar, but not identical, with flat roofs, rendered walls and suntrap windows. Some of the curved window glass has an abstract design moulded into it

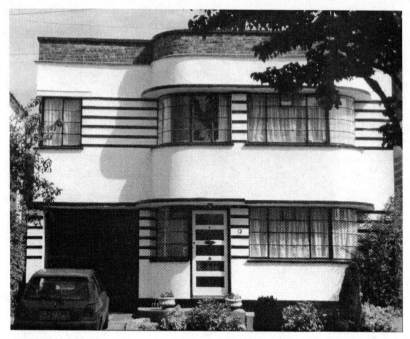

*Modernist house with corner and suntrap metal windows, concrete sun
canopies and horizontal banding. A brick wall guards the flat
recreational roof. Abbotshall Avenue, London N14*

which is very unusual. Painted in a variety of pastel colours the houses
present an attractive scene. One quirky note is the yellow brick parapet
surrounding some of the flat roofs. Others have been rendered and
painted to match the rest of the house.

An unusual feature of number thirteen is an external stone staircase,
leading from the garage roof up to a roof terrace, reached via a door at
first floor level. Next door the name LAGOONA is incised in large
letters at roof level. It sounds like Laguna Beach, California, the epitome
of the sunny outdoor life. Another is called SOLSANA, which literally
means sun cream in Italian but maybe the first owners liked the sound
of it.

Would-be sun lovers who bought this type of house soon realised
that flat roofs and four-inch concrete walls presented problems in
Britain's damp climate.

The houses built from rendered brick were less prone to damp
penetrating the walls but still had the flat roofs to contend with. In a
road nearby nearly half of the houses which originally had flat roofs
have now had pitched roofs added.

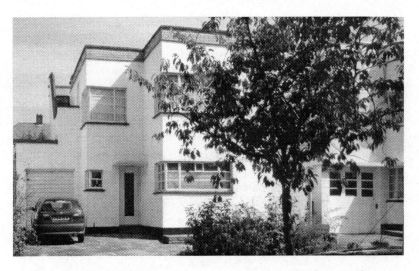

*Pure Modernism, this house has an outside staircase from the first
floor level reached by a door from the landing, just visible at the side.
Abbotshall Avenue, London, N14*

Adding a pitched roof brought trouble for the owner of a property
built in Meadow Walk, Harpenden, in 1938. Rapidly tiring of shovelling
the snow off the roof, to combat leakage problems three winters
running, he had a green tiled roof added in 1940. Not only was the
colour severely criticised by the Parish Council but also it attracted

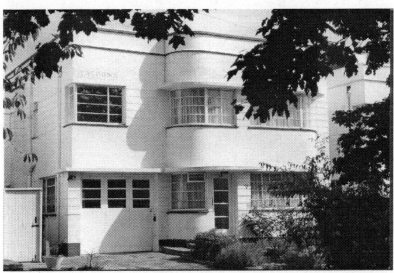

*The name LAGOONA is carved in the concrete on this rendered brick
Modernist house. Sun canopies, suntrap and corner windows make it
worthy of Miami Beach. Abbotshall Avenue, London N14*

the attention of the Air Raid Warden who ordered him to cover it up because the moon reflecting off the glazed tiles might attract enemy aircraft. The tell tale line of the old parapet can be distinguished and accounts for the height of the walls above the upper windows.

The original occupier lived in it for nearly forty years. Then it was sold, renovated and resold. The third owners could not understand why the large bedroom on the top floor was reached by such a narrow staircase. They were amazed to learn that it had once been enclosed in a small tower, and that the door leading to their bedroom had opened onto a roof terrace.

A pair of Modernist houses in Harpenden Road, St.Albans also suffered a dampness problem. This was solved by adding a ten percent slope to the flat roof that assists the drainage without showing above the ranch style parapet which would detract from the appearance of the facade.

The green roof was an after thought. The original
parapet line can be seen on the side wall. Harpenden.

This re-roofing phenomenon appears as far north as Sale, Cheshire, which has a nucleus of Art Deco Modernism focused on an Egyptian style cinema in Washway Road - does the name foretell problems with water? The last two of a row of flat roofed houses have pitched roofs which are later additions.

Cubism was a further challenge to architects of the Modernist Movement. But they succeeded in translating its fundamental principles of asymmetry, and abstract geometry to their work. 'High and Over,' Amersham, Buckinghamshire is a perfect example. Set at the top of a steep hill, the floor plan of the house itself is like a three bladed propeller. Built during the 'flying fever' period of record-breaking flights, it was dubbed the 'Aeroplane House' by the local people.

Now divided into two properties the exterior appearance is unaltered. Its stunning three storey hexagonal glazed stairwell encloses the chromium plated spiral stairs leading to the third floor suite. This opens out onto canopied roof terraces reminiscent of the bridge of the

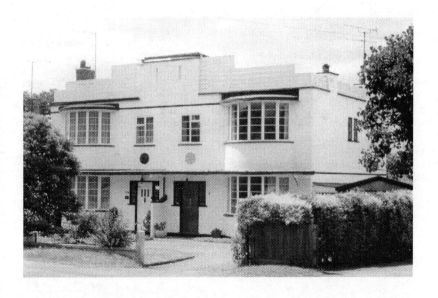

Perfectly symmetrical pair of semi-detached Modernist houses.
Harpenden Road, St Albans.

liner Queen Mary. Encouraged by the attention his masterpiece had attra ed, the architect, New Zealander Amyas Connell, planned to buik another thirty smaller houses lower down the slope. Only a few were built and remain as a series of square, white, flat roofed houses with glazed double height stairwells and cantilevered sun roofs shading the windows. Individual properties have been maintained in accordance with the original designs, but one or two have been ruined by modernisation.

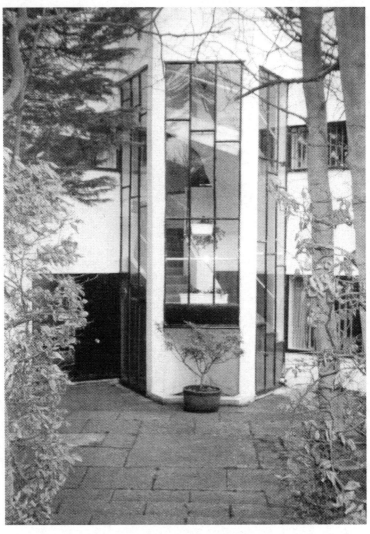

Hexagonal stairwell
High and Over. Highover Park, Amersham.

Originally advertised as Sun Houses, they are called The First Sun House, then The Second Sun House as they rise up the hill. Set well back from the road on the south side of Cambridge, another building called The Sun House has a double height semi-circular front banded by casement windows. A circular sun canopy which shades the roof terrace surmounting the adjoining single storey living rooms complements its rounded image. The cream washed walls and orange paintwork create an illusion of sunshine even on the greyest days.

Perhaps the most functional idea was invoked by the architect of Sunray, a Cubist house at Rearsby, Leicestershire built for a Dutchman who ran an adjacent nursery. Each bedroom has a door to a separate area of the first floor balcony which is shaded by a projecting area of the flat roof. In turn, the roof itself dries off comparatively quickly because it is more exposed than one with a parapet. This house, occupied by only two owners until the Nineties, retains the green and yellow paintwork so popular in a time when primary colours held sway.

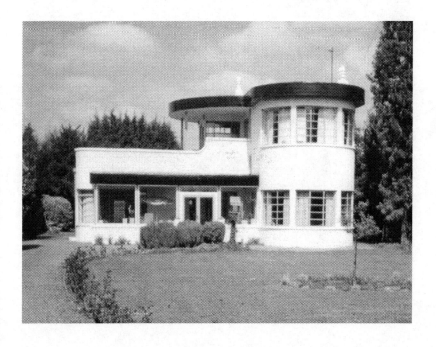

The drum shaped Sun House, full of Modernist features at
Queen Edith's Way Cambridge

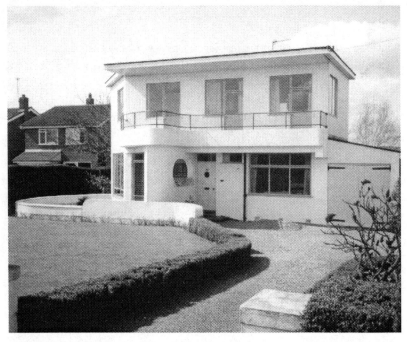

Each bedroom has a door on the first floor terrace at this Modernist House, which retains its original colour scheme. Rearsby, Leicestershire

A rare unglazed moon window breaches the wall between the front door and a terrace flanked by curving cream walls. A Modernist house could not be more perfect.

Such homes stood in abrupt contrast to the traditional styles of their age. Prospective buyers either loved the style or hated it. The majority chose to be cautious and settled for re-worked traditional styles, while a few more venturesome souls took a big step into the brave new world and opted for a Modernist house.

Public Housing

Not all new houses were for sale. Forward looking local authorities, striving to clear large areas of slums, built vast housing estates after the First World War. Huge developments such as Becontree and Dagenham which catered for people from inner London are usually cited as prime examples, but towns of every size invested in housing, and even villages would have a few council houses, usually at the end of the main street.

Councils, free of the speculative builders' need to attract buyers, were constrained only by the amount of finance available. This allowed the adventurous to plunder the more extreme styles of the time. Although the houses themselves were not elaborate, most incorporated some feature from contemporary architecture. Superficially they tended towards traditional styles, but closer inspection reveals details from almost every earlier architectural style.

The overall layouts were as well if not better planned than those of speculative builders, because the local authority usually had the advantage of already owning the site. They often grouped houses around a green recreational area or set them in a crescent. Some councils followed the Garden City school of thought and built cottagey styles along tree-lined avenues intending to give the appearance of leafy lanes.

For practical reasons local authorities were overwhelmingly in favour of Neo Georgian styles in line with public buildings such as libraries, schools and post offices. The mass production of metal window frames meant that small panes of glass could be used which had the advantage of being cheaper to replace when broken. But often a Moorish arch or some decorative brickwork would interrupt a Neo Georgian facade.

In North Hertfordshire Hitchin Council showed a broad minded approach to housing, featuring all the contemporary influences on one or other of their many estates. The High Dane estate on the edge of the town is unusual because it is Mock Tudor style, which is rare in public housing, owing to the cost. The wide timber makes a good effort to look like genuine supports for the building. Whereas in Sawtry, south of Peterborough, the wood on the half-timbered houses is so narrow it could never be anything other than decoration.

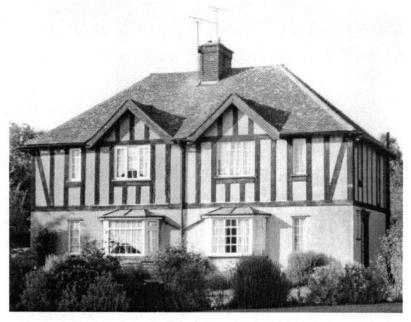

Mock Tudor style rarely chosen by local authorities because of its higher cost is shown here at Hitchin, Hertfordshire. The original windows are on the right.

Returning to Hitchin, at the other extreme in Common Rise near the station, Modernism rears its head as narrow double height metal windows on the staircases.

On the Westmill Estate along the Bedford Road, and out at Arlesey, Bedfordshire the houses feature Spanish arched porches of generous proportions, but this time they shelter two front doors with a vertical

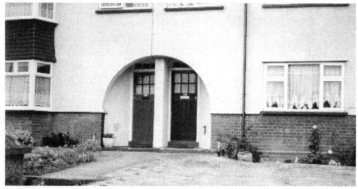

A generous arch embraces two arts and crafts style front doors on houses built by the authorities in Hitchin, Hertfordshire.

A tiny gablet gives a country air to this house built by the local authority at Kimpton, Hertfordshire

wall between them for privacy. Also on the Westmill estate the rustic look is reflected by gables clad in lapped cedarwood.

Such rustic details are rare but at nearby Kimpton, also in Hertfordshire, two pairs of houses have gablets - miniature gables - at the end of their roof ridges, of the type found on old barns. In contrast, next to them are two more pairs with Spanish style roofs where the pitch changes its angle just above the eaves. The local authority seemed anxious to vary the designs in the same way that speculative builders did because the next few houses feature an assortment of decorative brickwork.

In the north east of the county, off Weston Way, Baldock, the houses have decorative brickwork patterns over the central doorways of blocks of four, but most of them have been removed or painted over. Adjacent to these houses are others with dentillated banding echoing Classical styles. Yet more are built in pairs with big bay windows under gables and look like private housing of the time. And most unusual is a detached bay windowed house which suggests that it was intended for occupation by one of the council's officers. But a few roads away in Norton Way, Baldock Council built houses in keeping with traditional styles, with pseudo mediaeval jettied upper storeys and then put Spanish arched porches in them.

Many houses were cement rendered which looked rather dull but this was easily remedied by using the speculative builders' trick of

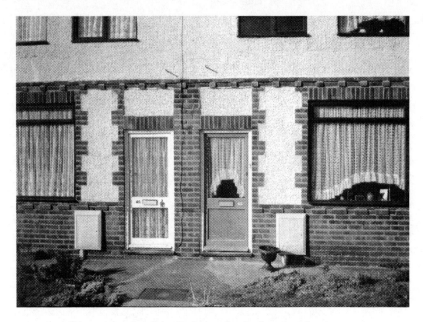

Decorative brickwork chosen by the local authority at
Baldock, Hertfordshire in the 1930s

inserting a few tiles. Placed in a variety of patterns it was a cheap and effective way to brighten up whole rows of houses.

Another inexpensive way to build a modern looking house was to have brick lower floors with the upper half rendered, to emphasise the horizontal lines, in the manner of Frank Lloyd Wright. This pattern is repeated throughout the country. Again in Hertfordshire, this horizontal theme is taken a stage further in the Marford Road, Wheathampstead, where white rendered houses have three courses of red bricks, stretching across the entire facade, immediately below the upper windows.

Decorative brick was used at Leighton Buzzard in a commendable effort to give a Queen Anne look to houses in Heath Road. The vertical emphasis successfully adds height and symmetry to the houses, with sash windows contributing to the effect. Although projecting porches have been added to the original design, the symmetry is maintained but is now slightly marred by the various front doors installed after the houses were sold to private buyers.

Often mistaken for council houses are three pairs of semi-detached houses built by Sir Piers Lacey, on his estate at Great Livermere, near Bury St.Edmunds. The houses have a simple band of soldier bricks

A jettied upper floor features on this council house
Baldock, Hertfordshire

around the upper storey at window level, another immediately below the eaves, and thirdly a row of over each of the downstairs windows.

Flat canopies shelter the original front doors, but the windows have been replaced. Retired head stockman George Lilley, moved in to one of the houses with his bride in 1939, when the house was new, and was still there in the 1990s. He continued the country custom of growing vegetables in the front garden which has a straggling privet hedge; and recalled that the same builder, apparently an admirer of Frank Lloyd Wright, put up several houses on the estate at that time. Just along the road, one of them, Street Farm, a larger, detached version of George Lilley's home, has brick corbels in addition to brick banding.

The real surprise unfolds a mile or so south of the village, around a bend in the road, to where the hand of the same architect is stamped on Wadgate House. First its white walls appear through the trees, and

*Decorative brickwork on a council house at
Wheathampstead, Hertfordshire emphasises the
horizontal line*

then the front of the house, with a superb rectangular porch, with four
orders in decorative brickwork, is revealed. The front door, plain black
with a long central glass panel, is original as are the black metal
casement windows. Beside the front door is a window with leaded
lights in an abstract design, and above it a larger matching one on the
landing. Isolated among trees in a field it looks as though it has strayed
from an affluent 1930s suburb. The three properties are solid evidence

*Decorative
brickwork
enlivens these
council houses
at
Pocklington,
near York*

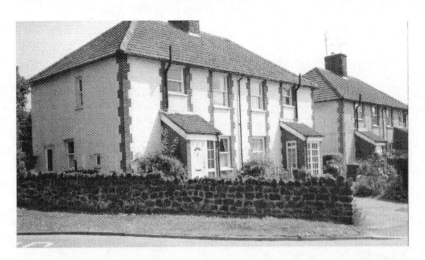

Decorative brickwork imparts a Queen Anne look to these houses at
Heath Road, Leighton Buzzard, Bedfordshire

that the new styles affected all levels of society, and not only in the towns.

On the outskirts of Bedford, Shortstown, built for the workers in the Short Brothers aircraft factory, has all the hallmarks of the Art Deco years, and was obviously a model estate at that time. But while every

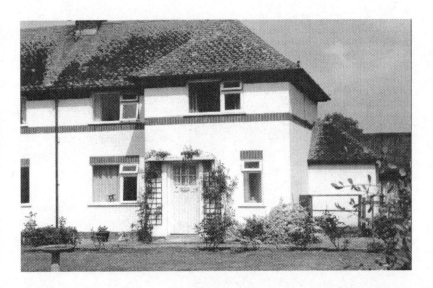

Estate house at Great Livermere, Suffolk, exhibiting the same decorative
features as the main house built in the 1930s

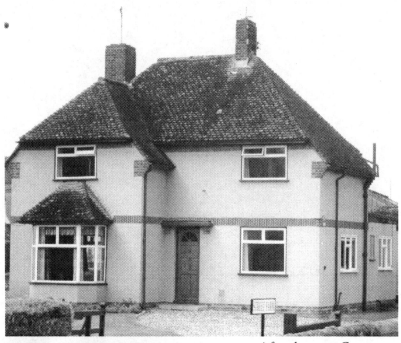

A farmhouse at Great Livermere, Suffolk, with decorative brickwork
The main house has a decorative brick doorway and original front door. All three houses bear the stamp of the same builder

house has some Art Deco detail splendid Spanish style colonnades front those in The Crescent. The houses are built in pairs with four brick arches stretching across the front. Unfortunately they are in a poor state of repair and some have had unsuitable replacement windows installed.

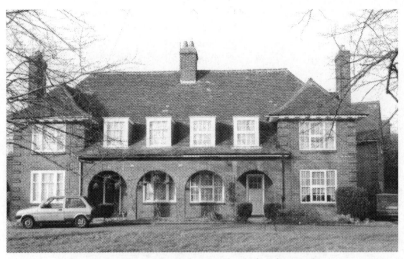

*A Spanish colonnade on houses built for the workers at
Shorts Aircraft factory, Cardington, Bedfordshire.*

In rural areas authorities often chose the cottage look, especially anywhere regarded as picturesque, to blend in with the existing architecture. Risinghall, near Diss, Norfolk successfully retained its

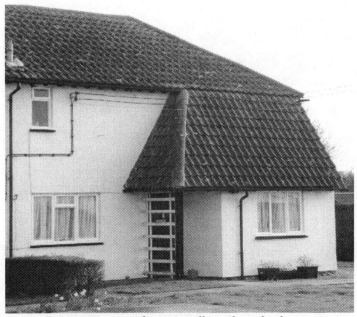

*Downswept eaves form a small porch on this house at
Little Kimble, Buckinghamshire*

Moulded concrete canpoy at Slip End, Bedfordshire

ancient appearance by placing cottage style homes at either end of the village which complemented the existing buildings and blended into the countryside.

At Little Kimble, Buckinghamshire, downswept eaves form two sides of the porch roofs with single supporting beams.

In neighbouring Bedfordshire fashionable hanging tiles were added to the upper corners of houses at Slip End. They contrast sharply with the moulded concrete door canopies below them which are more suited to Modernist houses.

A decorative brick 'porthole' reveals a nautical influence on this local authority house at Hempstead, near Saffron Walden, Essex

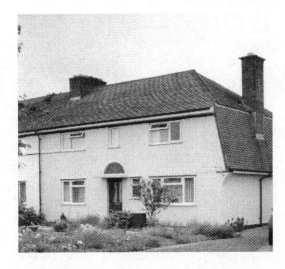

Former council houses at Burwell, Cambridgeshire have a decorative brick arch above the doors and a row of bricks along the roof line

The nautical influence appears as portholes above the front doors in a row of municipal houses at Hempstead near Saffron Walden; but confusion arises as they are infilled with decorative brickwork instead of glass.

Burwell, Cambridgeshire has a similar example of decorative brickwork in the form of a small infilled arch above the front doors of a long row of rendered houses. This time it is complemented by a row of bricks under the eaves and outlining the corbels.

Local authorities were responsible for some of the most innovative designs that appeared during the Art Deco years. They could afford to be more experimental as they were not spending their own money, nor did they have to find buyers. Most tenants were only too glad to be offered a new house to rent and were not bothered about its design.

In north west Essex, Saffron Walden Council produced a unique design for houses surrounding The Green in Little Walden Road. Three houses with Classical door canopies stand at right angles to the road either side of a rectangle of grass. Beyond it a symmetrical brick terrace full of contrasting styles forms the third side. The hipped roof is broken in the centre by a stepped pediment, flanked by six Venetian style windows. Unfortunately the original metal window frames have been replaced but their shape has been retained. Areas of white rendering surround the four doors to balance them with the larger central entrance. Within are sixteen one-bedroom flats for older tenants.

Some seven hundred prefabricated steel houses represent the machine age across the country. The Atholl All Steel House was produced in the Atholl shipyard at a time when orders for new ships were low after the First World War. Problems arose initially with the

Experimental steel houses on Watling Estate, Edgware, London

windows cracking due to expansion when the temperature changed. The Watling Estate in North London has over two hundred many of which have been purchased by the tenants. Only the lines of the framework and rows of rivets reveal their origins.

As with private housing Regency details are hard to find, but on the Southill Estate, at Cardington, south of Bedford, pairs of front doors are roofed with curving metal hoods, like a Chinese pagoda, similar to those seen over the ironwork balconies of the 19th century Regency houses.

Most of the foregoing examples are seen on large and small estates built throughout the country as the general standard of living rose. The first occupiers of these houses were families who had no chance of buying a home of their own. Many had lived in one or two rooms in inner city slums, others were poorly paid agricultural workers who were pleased to move into modern homes. Wherever they came from most regarded their new homes as 'little palaces.'

A Regency style metal canopy over a pair of doors screened by a dividing wall for privacy. Southill, Bedfordshire

Roofs and Chimneys

Colourful roof tiles in warm shades of red, orange and brown became fashionable during the building boom in the Twenties, replacing the slate roofs, which had fallen out of favour by the end of the First World War. Different coloured roofs on adjacent pairs of houses was yet another way of giving otherwise identical houses an individual appearance.

The hipped roof was the most popular on large developments, its symmetry giving a balanced look to semi-detached houses, especially with a pair of gables breaking the roof line at the front. The truncated hipped roof was among the post war starters but its popularity was soon ousted by the full four-sided version.

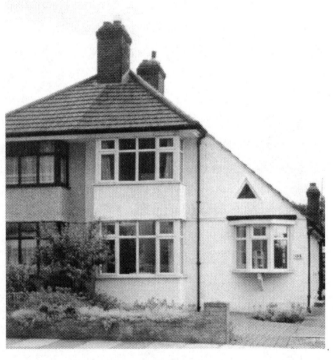

*Unusual triangular porthole under a catslide roof in
Carlton Road, Gidea Park*

Alongside the hipped roofs the cottage style flourished suggesting as it did a warm and cosy country home. Speculative builders frequently achieved this by placing a single gable in the middle of a pair of houses with eaves sweeping down to form a porch on either side. This low roof look is reminiscent of an 'outshoot' which was a mediaeval way of covering an outside staircase built to do away with the need for a ladder inside. This feature became known as a catslide roof and was later extended to enclose an oven or run the full length of a house emulating the side aisle of a mediaeval barn. Underneath the original ones would have been pantries or storerooms and they were thatched or tiled like the rest of the roof. Chalet bungalows were the Thirties version of this style with catslides sheltering boxrooms, kitchens and downstairs bathrooms.

Less common traditional roofs such as the gambrel type which has a double pitch on two sides with gable ends, and the mansard roof

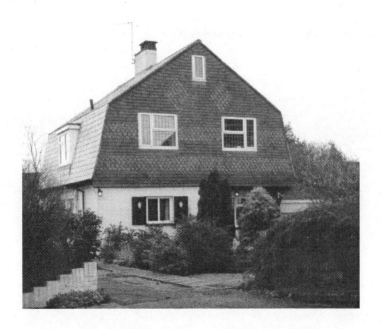

*Gambrel roof with patterned hanging tiles on the gable end.
Amersham, Buckinghamshire*

with a double pitch on four sides were used in the Art Deco years. They were costly to construct and normally reserved for architect designed houses. The gambrel roof looked especially attractive when its gable ends were tile hung because the large area allowed plenty of scope for multicoloured patterns.

Dormer windows were another way of adding a traditional touch and also useful for varying the facades of pairs of houses on large estates. Appearing in many shapes and sizes there are four types, simple, gabled, hipped and swept.

The simple dormer rises in a triangular shape providing space for the insertion of a window. Normally it is set on the line of the eaves. The gabled dormer has perpendicular walls to give it height and so allows a larger window to let more light into the interior. As its name suggests it has a two-sided roof, and the same type but with a three-sided roof it is known as a hipped dormer. The swept dormer is the mainstay of picturesque calendars. Lifted straight from the roofs of old thatched cottages it simply curves uninterrupted up and over a window, permitting the wind to flow over it while keeping the possibility of damage to a minimum. A very shallow swept gable on a house in Harpenden shelters not a window but a decorative Japanese sunburst in the rendering of the wall.

Even the gablet, so beloved of cottage dwellers, re-appeared in significant numbers. These tiny gables are usually just below the end of the ridge of an otherwise hipped roof. Single houses in rural locations are a more likely place to see one than in the suburbs.

One rarity with ancient origins is the turret roof. Although it found favour with the Victorian architects it was not suitable for buildings of the Art Deco years. A few incorporated in the more pretentious mock gothic houses blend in but those found on typical Thirties houses look completely out of place. And one on a bungalow looks absurd.

Deep eaves, worthy of Frank Lloyd Wright, symbolise shelter, and are common on inter-war houses. The depth recalls the thickness of the eaves on thatched cottages and the braces are sturdy enough to support an entire haystack. Where a roof covers a deep bay window, large areas of boarded eaves flank the curve often with generous braces. Such a roof is visible in Narberth, Dyfed atop a pair of semi-detached houses which have Modernist metal window frames set in large bays, and Spanish style porches. Obviously the architect intended to be really up-to-date but at roof level his courage failed him. Maybe he thought better of putting a flat roof on a house where the rainfall is so high. Not only did he incorporate deep eaves and heavy braces but

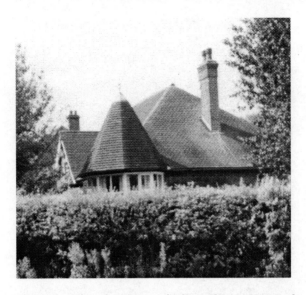

Turreted roof on the corner of a bungalow in Harpenden

eschewing all the colourful tiles that were available reverted to a traditional Welsh slate roof.

Roofs were not left out where the bold colours of the Thirties were concerned. Green glazed tiles were introduced, some of them almost luminous and others with a red flush simulating those used on Roman villas in the 1st century AD. Manufactured in Holland they were

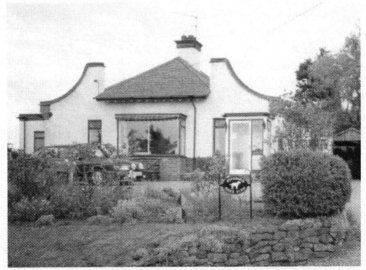

Bungalow with truly flying buttresses looking oddly out of place with the slate roof. Heacham, Norfolk

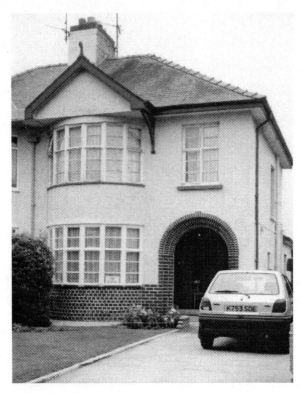

A cocktail of Thirties styles with a traditional Welsh slate roof.
Narberth, Dyfed

considered outrageous in the more conservative areas of Britain. Small developments were built with green roofs, such as The Chilterns in Hitchin, but the colour was generally considered too risky by builders aiming at the mass market.

Architect Frank Salisbury built The Dutch House and The Spanish House in Harpenden, both with bright green tiled roofs. A soaring white gable curling skywards is the focus of The Dutch house. Another high white gable with green roof surmounts the garage and there are two more on the back of the house. The Spanish House has similar tiles on a hipped roof which changes to a very shallow angle just above the eaves.

Both houses are visible from the opposite side of the town. When they were built in the mid-Thirties people regarded them as an intrusion and bombarded the council and the editor of the local newspaper with letters of complaint. A cottage style house in Cambridge has similar bright green roof tiles, which look quite odd protecting its dormer windows.

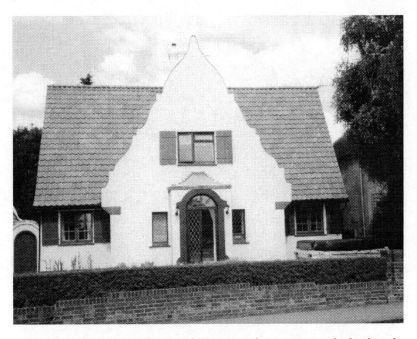

A massive gable fronts the 'Dutch House' with two more at the back and another on the garage. Harpenden, Hertfordshire

Most daring of all were the blue glazed tiles. Although few in number they certainly made an impact. Brilliant sky blue tiles sparkle on properties as varied as a lone house in Empress Avenue, Farnborough, flats in suburban Southgate and in rural Ringshall,

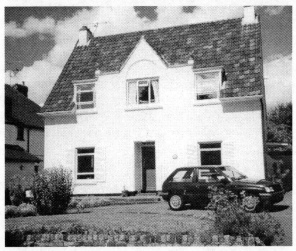

This brilliant blue roof looks best on a sunny day (and in colour). Empress Avenue, Farnborough, Hants

*Bright blue glazed tiles top a pitched roof section of
Gwalior House, Southgate, North London*

Hertfordshire. The lone Modernist house is among others of its vintage
but in more traditional styles. The flats are a large brick block with a
flat roof but steeply pitched sections tiled in bright blue surmount two
of the entrances and are complemented by horizontal lines of matching
tiles running along a brick balcony. Blue Cottage, Ringshall is simply
a one off white Modernist dwelling standing out among green
woodland at the end of a small village.

Softer blues some flushed with grey are more common and could
almost be described as plentiful in West London, around the Rayners
Lane area. And a few grey glazed tiles are found, certainly in the
London suburbs.

Chimneys offered great scope for stamping an individual look on
houses at comparatively little cost. What appear to be unnecessarily

high chimneys on many houses is merely an echo of the tall cottage chimneys which were necessary to carry the sparks away from a thatched roof. But many architects took advantage of the height and banded or stepped them in skyscraper style, so stamping them with a Modernist mark; although the house underneath might be an anthology of traditional building styles. On white rendered houses the chimney was often topped with a few courses of bricks and some had a thin layer of tiles inserted as a band below them, all for purely decorative purposes.

Others went to the opposite extreme and copied the highly decorative brick chimneys of Tudor times when both bricks and chimneys were a comparative novelty. Before the 16th century chimneys were not in common use, only the rich had such luxuries.

The pitched portion of the roof has bright blue glazed tiles

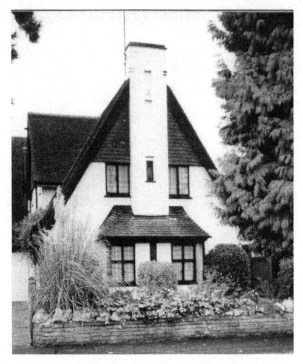

The 'Skyscraper' style chimney. New Bedford Road, Luton

Smoke from an open hearth simply found its way out through the roof. But the widespread increase in brickmaking brought the cost of chimneys within the means of yeomen farmers. They were easily incorporated in the structure of new houses. But the ever resourceful country folk in their timber framed houses inserted them within the structure or built one against an outside wall. The latter gave rise to a fashion for external chimneys that still persists. Art Deco builders commonly used chimneys as a decorative feature, constructing them in natural stone or in brick, often to stand sentinel as pairs of tall chimneys adding balance to a symmetrical house.

Other protruding chimneys had 'tumbled in' bricks, typical of the 17th century stacks, for decoration. This involved keeping the edges of the bricks at right angles to the line of the slope of the projecting chimney. They were set in triangular sections and were intended to present the strongest surface to the elements. This feature was favoured more by 20th century architects in the north of England than in the south and is particularly plentiful around York.

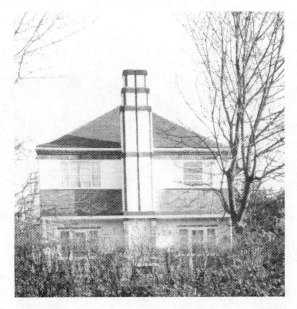

Skyscraper style chimney on a house at Edgware. Middlesex

A rare Art Deco version of 'tumbled in bricks' appears on a house in Streatley, Berkshire where a small triangle composed of edge on tiles has been 'tumbled in' half way down a white rendered gable.

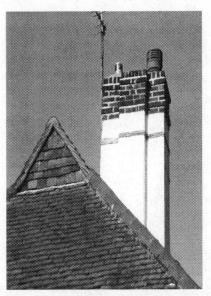

Decorative brick chimney top above a tiled band.
Southdown Road, Harpenden

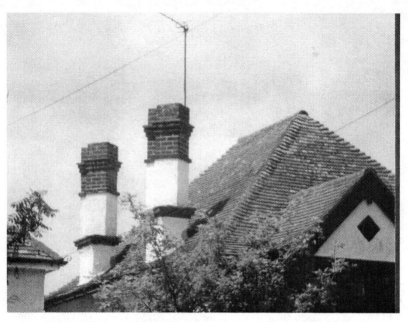

*Diagonally set in Tudor fashion, on square bases, chimneys in
Harpenden Road, St Albans*

The black diamond diaper pattern familiar on Tudor brickwork has
been copied as a single strip on the side of Thirties chimneys. Other
builders used natural stone blocks for just the top few courses of a

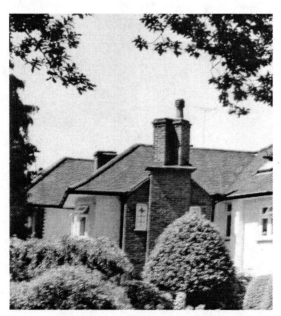

*Tudor style
chimneys on
Twenties house
Arnos Grove*

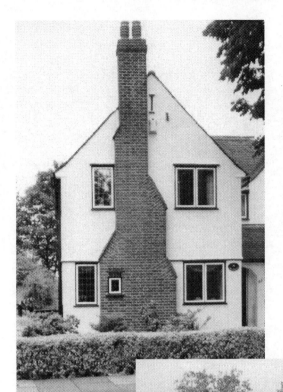

Tumbled in brickwork features on the chimney of this house in Gidea Park

Diaper brickwork on a chimney in Harpenden

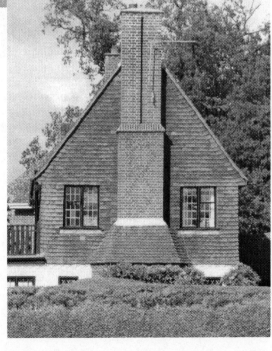

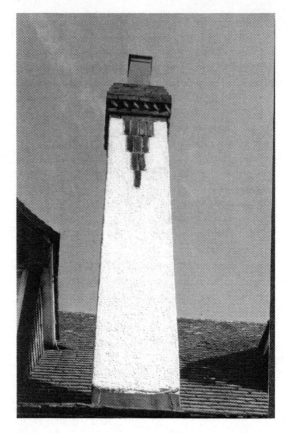

Decorative brickwork on a chimney in the Ridgeway,
Cuffley, is one of many built by Hicks, a local builder

chimney to add a rustic look to an otherwise modern house. But perhaps the most attractive are those thought up by individual builders that marked their houses. A Peterborough builder chose a Classical look for the chimneys above a parade of shops by incorporating Byzantine banding. Hicks, a Hertfordshire builders, erected tall white rendered chimneys with a distinctive half drop pattern in bricks around the top which immediately stamped every one of their dwellings around Potters Bar, as a Hicks house.

Off Mill Hill Broadway one builder inserted a broken vertical line of bricks in rendered chimneys in Woodland Way, but the mass market was unconcerned about the name of the builder or the historical accuracy of the style of their houses. All most people wanted to achieve was their own roof over their heads.

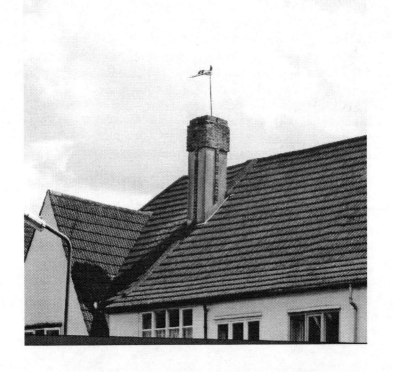

Decorative brick chimney in Woodland Way, Mill Hill

Metalwork

Metalwork displayed in the Paris Exhibition of Decorative Arts ranged from furniture and lighting to jewellery and pure ornamentation. In the outside world, intricate panels of wrought iron, stainless steel and bronze framed the doorways of public buildings in imitation of those on New York's skyscrapers. Architects adapted the designs for use on the gates, grilles, and railings of individually designed homes. The speculative builders' use of decorative metalwork was mainly limited to the hinges on Mock Tudor doors and to balconies and window catches. But its scarcity is more than compensated for by the amount on buildings put up to serve the residents of the new estates.

Where houses based on traditional styles were concerned some incorporated an upstairs French window, which was a favourite place to embody modern metalwork. Railings splaying out at the top were a

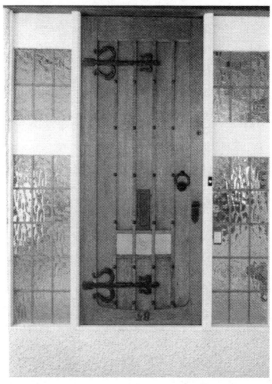

Heavy Tudor door with decorative hinges and furnishings.
The Ridgeway, Cuffley, Hertfordshire

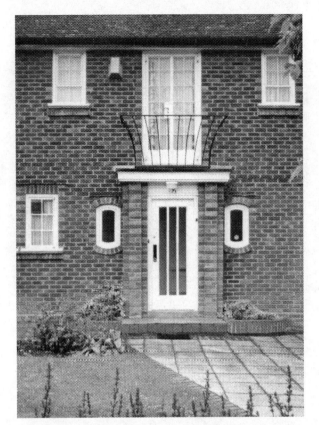

Splayed railings to give the illusion of space.
Highfield., Letchworth

subtle way of enlarging a balcony which could never be anything other than ornamental because of its small size. Similar to Georgian balconets in being too small to stand on, they were edged by what were essentially guard rails to stop the inhabitants from falling out of the windows. Many houses in Hampstead Garden Suburb have decorative ironwork gates and balconies and some excellent ones on flats. In The Market Place, over the shops one series looks like notes of music attached to a few upright rods.

The various Art Deco influences were reflected in diverse ways. The country living theme was used by architect T.S.Tait for the metal balcony railings on a Modernist style detached house at Silver End, Essex, built for the Crittall Company. Close inspection reveals them to be cast with a textured finish simulating tree bark.

The sun and moon motifs, so beloved by Japanese artists, were included in railings either in wrought iron or as flat silhouettes.

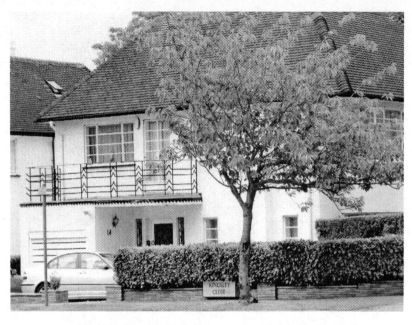

Aztec design railings, Hampstead Garden Suburb

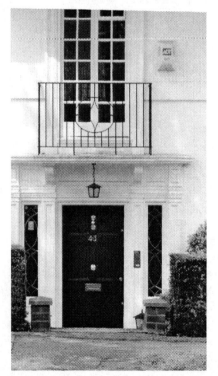

*Ironwork balcony.
Northway, Hampstead
Garden Suburb*

Horizontal railings were popular because their streamlined effect suggested nautical lines. To join them together they would either be linked by a central geometric motif, or have a minimum number of vertical bars.

Often they were curved at either end like a ship's bridge. One such balcony in Lytton Close, Hampstead Garden Suburb, fronts a full height glazed door with suntrap windows curving away on either side of it. A couple of houses away a similar nautical balcony

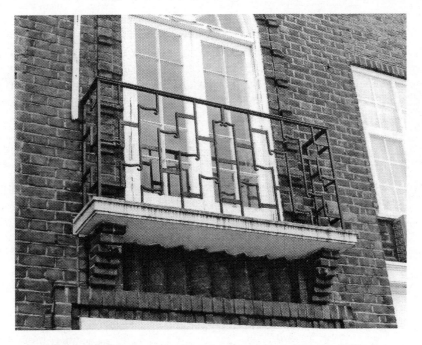

Balcony railings. The Market Place, Hampstead Garden Suburb

shades a glazed front door which has a central metal rod with S shapes branching off it.

Railings with a horizontal emphasis. Whetstone, North London

So many nautical details are found around the London Underground Station at Rayner's Lane that visitors could be forgiven for thinking that they had arrived at the seaside. The station itself is a functional brick, metal and glass building with a turret in Modernist style. Its most unusual feature is the entrance which has a flat roofed area stretching from the main block across the pavement to a single storey brick building; this is elliptical with suntrap windows in its semi-circular ends.

Adjoining the station seven or eight parades of shops are topped by vertical railings, less than half a metre high, with a simple motif at either end of each section. They surround roof terraces which serve deck access flats, set several metres back, to provide an open area above the shops.

Opposite the station is a well preserved former cinema, which is still an entertainment centre. A huge wave shaped column painted

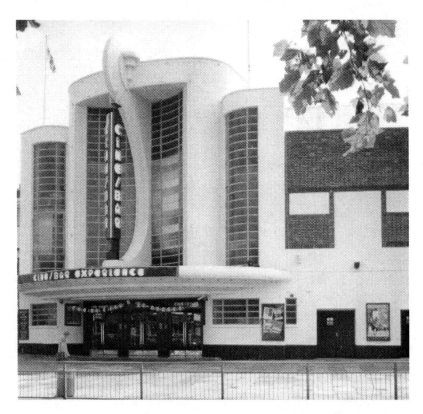

Curvilinear cinema at Rayners Lane

Nautical influence shown by a 'wave' design on this metal grille above the entrance to flats at Rayners Lane, London

pink and reputed to represent an elephant's trunk forms a vertical division in the centre of the front. A revolving triangular sign once hung from the top like a ship's sail. Either side of it a curved chequerboard of glazed metal window frames towers above a nautical style canopy. Wrought iron waves flow ceaselessly across a grille between some shops in Rayners Lane itself, while across the road

The nautical influence represented by a 'wave' of green tiles along a block of flats at Rayners Lane, London

*Wavy pattern metalwork on the open stairwell of
Chase Court, Southgate, London*

ardent seafarers would delight in the wavy line of sea green tiles
running the full length of the cream facia of a parade of shops. Further
echoes of the sea are reflected by the varying shades of blue roof tiles
on other blocks. The wavy motif appears on ironwork in the stairwells
of Chase Court, Southgate which also has ironwork balconies. Across
the road Gwalior House mentioned in the chapter about roofs has
decorative ironwork on the staircases and on three small gates in the
boundary wall.

Balconies above the entrances to blocks of flats lend themselves to
decorative railings, as do the windows at the same level. Welwyn
Garden City has a fine row of balconies above the shops outside the
station. Each pair of French windows opens onto a metal balcony
surrounded by railings in a curly design which incorporates golden
balls. In contrast a parade of shops in St.Albans has strictly geometric
railings running the length of the building. They are purely for
appearance because the flats which overlook it have no access apart
from climbing out of the windows. For appearance only certainly
applies to balconies above a bank at Heathway, Dagenham. Set against
a blank wall between the first and second floor windows they have
no access and no practical use. Fanlights above street doors that lead
straight upstairs to living accommodation over shops were also a
favourite position for decorative metal grilles.

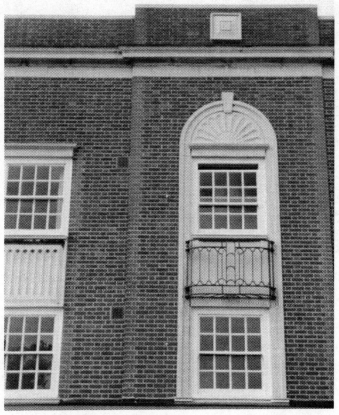

Decorative balcony, Hedgemans Road, Dagenham.
No door, no floor, no use.

Symmetrical abstract designs were the most popular but contemporary symbols are reflected in places. The outline of a Dutch gable appears on metal grilles in shopping centres as far apart as Cardiff and Harpenden.

Its symmetrical curve, with a step in each side, shows that even blacksmiths kept up with contemporary ideas. Its unmistakable shape is incorporated in the arched entrance doors and the balconies of The Pantiles, a block of Modernist flats that caused a commotion when they were erected in 1935 amid Neo-Georgian surroundings in Temple Fortune, north London. The original cream and green colour scheme, faithfully preserved below the green glazed roof tiles flushed with red, proved too outrageous even among avant-garde Londoners.

Dutch gable design in metal grille over entrance to flat above shops in Harpenden, Hertfordshire

Other motifs such as stylised flowers and animals can still be found. Visitors to London can see a splendid pair of doors at the entrance to luxury flats at 32 Grosvenor Street, where a rainbow of shining steel set in the glass, arches down to five horizontal strips all encompassed by a black metal frame. And it is always worth looking at Broadcasting House berthed like a great ship at the top of Portland Place. The plainness of the outside is relieved by the metalwork chevrons on the doors and the railings edging the curved stepped upper floors.

The railings around the roof terraces on Modernist houses often have designs reflecting Art Deco themes, ranging from the subdued to the spectacular. Old Hunstanton, Norfolk, has mainly heavy duty balcony railings, which are nearly all linear

Dutch gable design above shops in central Cardiff

Art Deco doors on luxury flats in London's Mayfair

designs, around the roof terraces of its seaside properties. They are
so solid they would repel all invaders. The only curves to be seen are
in a couple of robust garden gates. The Aztec influence is depicted on
five remarkable Modernist houses in Stanmore where the extensive
roof terraces are guarded by horizontal bars interrupted by Aztec
chevrons.

This same Aztec design appears in the most unexpected places.
Among the Victorian facades of Harrogate's shops at least two first
floor windows boast metal window frames with Aztec opening lights,
no doubt put in by a shop owner keen to modernise his premises in

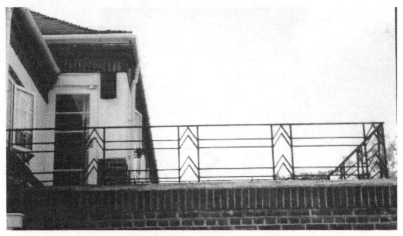

Decorative metalwork railings surrounding the roof terrace of a house in Edgware, Middlesex

the 1930s. And there is a sighting of a similar window in Wetherby for anyone driving through on the main road.

The Post Office, which built many new offices during its expansion in the 1930s, was an exponent of Art Deco, although the Georgian style, which was so popular for public buildings, was selected for most of its new buildings. Stowmarket, an ancient market town in Suffolk, seems at first glance to have a Neo-Georgian Post Office. But

Miami style with stepped glazed stairwell and decorative metalwork railings. Valencia Road, Stanmore, Middlesex

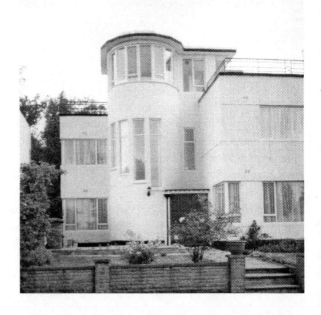

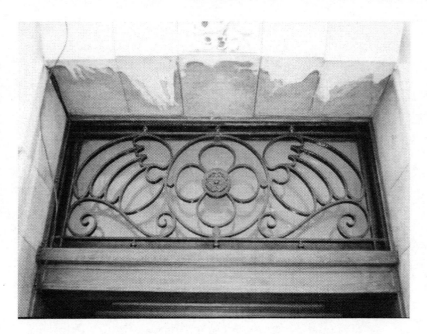

The Post Office grille at Stowmarket, Suffolk

the architect could not resist placing two Classical urns on top of the parapet and including some decorative brickwork at the corners. Then he abandoned the Georgian idea completely and best of all inserted an Art Deco metal grille above the door, with a Tudor rose in its centre for luck.

Cinemas with no tradition to follow quickly embraced the newest styles and often incorporated ornamental metalwork. The Broadway Cinema at Letchworth, begun as Britain's first garden city in 1903, has four glazed grilles, about six metres high, which illuminated the former restaurant and the stairwells. A regular pattern of circles and zigzags fills wide lofty spaces. They completely overshadow the eight glazed metal entrance doors which incorporate the 'Dutch gable' design. In the town itself, around the Broadway area, are examples of balcony railings around flat porch canopies, all of them uncomplicated geometric designs.

Early garages were mainly enlarged blacksmiths shops but as the machine age expanded and arterial roads proliferated new garages appeared. Again with no tradition to follow they adopted modern lines. Older readers will recall the cream coloured streamlined showrooms with clock towers that sprang up in the Thirties. But few can compare with a former garage near the South Gate, in King's Lynn. There the word 'ford' in two metre high lower case metal letters is set

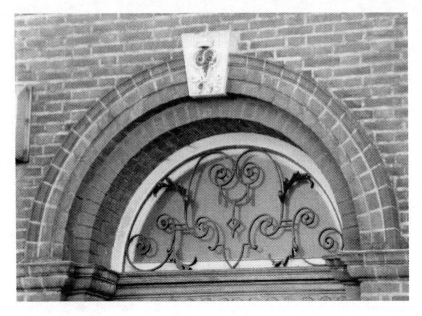

Grille on the former Post Office, Royston, Hertfordshire

in the upper wall of the building with the 'o' and the round part of the 'd' glazed to form windows.

Further west in Leicester the fire station must be near the top of the list for Art Deco interest. Each of the four sides of its cream tower has a clock face in decorative metalwork and a balcony with complementary railings. The whole edifice is surmounted by railings around its flat roof, which affords a fine view across the town.

Throughout the country wrought iron archways over public paths displaying the name of the street or place it led to were not unusual, but rust has taken its toll and only a few remain. Among them one at Southwold curving over the entrance to the seafront park still entices visitors with the words BOATING, CAFE and LAKES, conjuring up dreams of a green and pleasant land.

No mistaking that this was once a car showroom.
Kings Lynn, Norfolk

*Decorative metal arch - boating, cafe and lake -
above entrance to a park at Southwold, Suffolk*

Gardens

If the suburban home was the Englishman's castle, the garden around it represented the grounds surrounding the property of a landed gentleman and as such was carefully nurtured. A walk around any Thirties suburb reveals that ninety nine percent of the garden walls have a common feature although it is expressed in a variety of ways. Wooden posts or brick pillars establishing the territory of the homeowner invariably define the boundary of each plot. Chains which have mostly disappeared now, or low walls linked the posts. These posts and links are merely a watered down version of a curtain wall with towers which surrounded a mediaeval castle. The garden walls consist of two or three courses of brick often laid in a decorative pattern, or curved in a gentle bow. The low level emphasised the open country, fresh air aspect of living, but served to repel trespassers.

Architects, in an effort to relate the front wall to the house, sometimes put ridged tiles on top of the posts, and occasionally tiled the entire

Typical chain and post boundary wall, Potters Bar

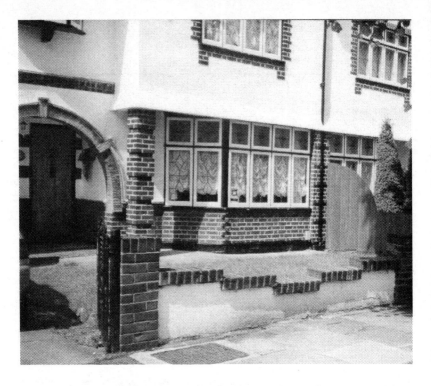

Wall stepped Aztec fashion, Gidea Park

top of the wall to match the roof of the house. Others matched the wall to a pediment on the house and Modernists simply rendered the wall and posts and painted them cream or white.

Some walls had both chains and brick courses; other low walls had symbolic posts represented by bricks standing on end and built up in steps at intervals. Privet hedges were planted behind the walls to reinforce the green image of life in the country but they were clipped along tight geometric lines to reassure the residents that nature was firmly under control. The more daring gardeners aspired to golden or variegated privet that provided light relief among the sombre green.

Another material used to create a rustic effect was the waste from furnaces. Huge quantities of this clinker were produced in order to meet the demand for gas for the domestic market and coke to fuel the Ideal Boilers which heated the water in many of the new houses. The clinker, in lumps slightly larger than bricks is often shiny or has holes in it and comes in a variety of soft colours which blend well into the browns and greens of gardens.

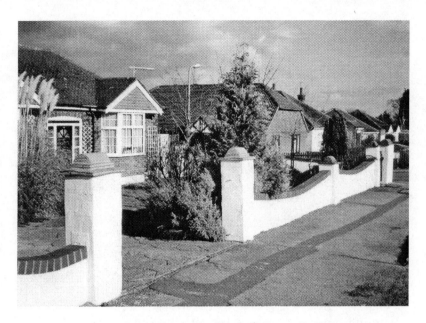

Decorative garden wall,. Chiswell Green, St Albans

The same influences which affected the houses were at work in the garden. Pure Spanish arches in warm red brick form the boundary wall of a property on the A41 near Aston Clinton. A few more opulent

Tiled wall and posts. Beck Row, Mildenhall, Suffolk

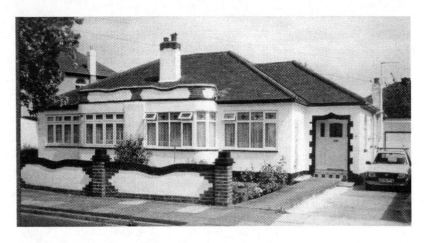

Decorative brickwork enhancing a pair of bungalows with matching wall and pediment. Gidea Park, Essex

houses had higher walls in the Spanish style, pierced by wrought iron gates and perhaps an opening with a metal grille.

At Sandwich Bay, one house is fronted by a white rendered wall. Its arch shaped entrance has its own miniature hipped red roof, to match the main house. The circular design of the metal gate set in the opening, contrasts with the vertical metal bars which safeguard the six arched openings flanking the entrance.

Modernist wall incorporating what was then - a novelty light

The cottage chimney pots look for this post and link garden wall.
Harpenden Road, St Albans, Hertfordshire

A tile topped rendered wall which curves around the corner of Richmond Avenue, Bexhill, incorporates six miniature arches. Each one, about thirty centimetres high is like an unglazed window with its own red tiled sill.

Arched design garden wall in black and white marble.
New Bedford Road, Luton

*A fan-shaped opening, with a metal grille, in a wall screening a
swimming pool. Townsend Lane,
Harpenden*

A fan shaped opening, complete with
grille, appears in a high rendered wall
adjoining a house in Townsend Lane,
Harpenden. Two archways with similar
wrought iron gates complement the fan,
while behind it is an outdoor swimming pool.

Not many walls can be thought of as
nautically inspired but at Old Hunstanton a
beautiful wavy topped wall reflects its
nearness to the sea.

*Metal gate with mediaeval
style finials, at the side of
a garage with decorative
brick 'soldiers' on lintel
and Mock Tudor
ornamentation*

*A fat impenetrable hedge backs this garden wall
in Old Hunstanton, Norfolk*

Far inland, in Gidea Park, a white rendered wall with a similar wavy top, complements a white house with suntrap windows. In the next road a white wall, with a top stepped Aztec fashion, fronts a house with matching decorative brickwork.

Strong nautical influence on this symmetrical rendered wall, Gidea Park

Wavy detail in open section of a gate in Chiswell Green, St Albans

In the north of the county, at Saffron Walden, some local authority houses have a wavy wall along a complete terrace. Still in Essex, a wall in Frinton is pure 'anything goes.' Between its upright wooden posts different coloured bricks, edge on and patterned tiles, half pipes, and building blocks are mixed with abandon to form the linking panels.

The mandatory garden gate was made of wood or metal. The wooden ones were usually solid at the bottom with an open design in the top half. A unique gate in Hampstead Garden Suburb has foot high carved letters ONE filling the top section of the gate, harking back to the Arts and Crafts Movement. Many others had wavy edged strips showing a nautical influence but the Japanese sunburst was by

A hint of a sunburst in these two tone gates at Harleston, Norfolk

Sunburst metal gate. Hampden Way, Southgate

far the most common design, appearing as a quadrant on a single gate or a half circle on pairs of gates. Most have disappeared as the wood has rotted or gates have been removed to allow easy access for a car. The sunburst was also a popular design for garden furniture.

The word SUNSPAN on the metal gates of a house on Portsdown Hill, overlooking Havant, describes them perfectly. No doubt designed as a whole by the architect of the beautiful Modernist house behind them.

A hint of a sunburst is the basis of the design of a pair of tubular steel gates guarding the drive of a bungalow in Harleston, Norfolk. A reminder of the fashion for two-tone paintwork, the vertical bars at the bottom are painted bright green and the top ones cream. Because they stood permanently open, the occupant was about to have them taken off and dumped although they are in good condition. When she discovered that they were of historic interest, they were granted a reprieve. Another highly individual pair of metal gates in Leeds Road, Harrogate has the number 153 incorporated in the design of the gate so that no one can miss the house.

Sunbursts even invaded garden seats

Contrasting styles are found in a number of individual gardens. An ornately carved lych gate at St.Albans, matches the porch of the Tudor style house it fronts; but it is set in a curved rendered wall in Modernist style.

Handmade gate incorporating the house numebr. Leeds Road, Harrogate

Lych gate matching the porch of the house, set in curved Modernist wall.
Harpenden Road, St Albans

Modernist houses often had cream rendered garden walls, some
low and streamlined, but many in the familiar pillar and panel style.
A lone example of Modernism looks out of place facing the perimeter
wall of the Bishop's Palace at Ely, where three brick pillars are joined
by pebble dashed walls with diamond shaped raised panels.
Modernism at its most streamlined has also invaded Hatfield Road,
St.Albans where a low arc of pink washed cement forms a barrier
between the garden of a chalet bungalow and the pavement.

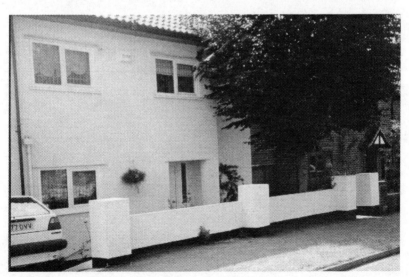

Modernist version of the post and link wall. Harpenden Herts

Geomteric panels feature on this pebble dashed post and link wall within the shadow of Ely Cathedral

A garden was essential to the new owner-occupier generation, as it separated the house from its neighbour. While the detached house with land all around it was desirable, it was beyond the means of the masses. The semi-detached house was king as the access at the side meant that the front and back gardens were linked, thus distancing the house next door.

Unique bowed wall in front of a symmetrical chalet.
Hatfield Road, St Albans, Hertfordshire

Front gardens had the mandatory lawn, no matter how small, with symmetrical flowerbeds. Back gardens, the majority of them rectangular, lent themselves to being divided by a trellis into the vegetable garden at the bottom - fostering the living in the country image - and an area near the house with a terrace, flowers and a lawn.

To cater for the enthusiastic gardeners, plant nurseries began to appear. Harkness Roses at Hitchin opened for business in a symmetrical green roofed bungalow with a classical verandah, which is still there. Formal standard roses stood sentinel either side of thousands of front garden paths wafting their delicate scent over everybody approaching the front door.

The symmetrical flowerbeds lent themselves to orderly planting which led to the growth of the bulb industry. Tulips, and to a lesser degree daffodils, are well suited to being set in rows parade ground fashion.

Dutch growers came to Britain and set up nurseries to cater for the demand. One arrived in Rearsby, Leicestershire, building a small bungalow with an impressive Dutch gable on his land. Trade flourished and he went on to build the outstanding Modernist house mentioned in the chapter on Modernism.

Harkness Roses original green roofed symmetrical bungalow.
Hitchin, Hertfordshire

The garden path is also a clue to the age of a house. Crazy paving first made its appearance in the early 20th century. Again confusion reigns. On one hand its texture is broken in a random pattern declaring 'anything goes' but on the other hand geometrically faceted edges confine it within a careful outline; making order out of chaos in the same way that the gardens themselves represented the countryside, but strictly within bounds. Crazy paving doorsteps were often laid in a fan shape, as were sun terraces, but as they are usually in back gardens they are not visible from the street.

Ornamental garden pools were an essential feature for those wanting to echo the village pond aspect of country life. Fish, fountains and water plants flourished in round, square and oblong pools, while the more ambitious gardeners aspired to fan and key shapes. Elm Park Court, a green roofed, white walled block of Modernist flats at Pinner Green is set around a well kept, colourful garden which still has a huge key shaped pool as a main feature.

In Lyndhurst Drive, Harpenden, one house has a rill running right through the front garden which has to be crossed by a tiny bridge in order to reach the front door. Some would-be gardeners had a hard time cultivating their land, which was not always the fertile soil they

A fan shaped garden pool. Harpenden

Part of a key shaped pond, Pinner Green

had dreamed of. All the clay excavated from the tunnels when the London Underground train network was extended to Cockfosters was dumped in the low-lying area around Pymms Brook in East Barnet. This land was rapidly covered in houses purchased by thousands of innocent buyers arriving by the new streamlined trains to view the expanding estates. Many gardens still looked raw after several years of tender loving care. Roses were an exception. They flourished in the clay which contributed to their rise in popularity.

A garden was considered essential for children to play in and for family relaxation. Garden swings were in vogue and tea would be taken outside if the weather was fine.

The more affluent had a garden chalet with a verandah enabling them to sit outside even if the weather was cool. Such chalets were often rustic in appearance being constructed from cedar wood and roofed with shingles. Garden sheds joined the fashion stakes with glazed French doors, the occasional insert of stained glass and electric lights. One still survives in a garden in St.Albans. As electricity was still a novelty, outdoor lighting was a status symbol and found in the gardens of the better off but rarely found on suburban estates. Exceptions were Modernist properties where forward looking architects placed lights low down at the end of the driveways. Some of these can still be seen.

A rill with a bridge to cross to reach the front door.
Harpenden, Hertfordshire

To keep costs down, thousands of houses were set in blocks and terraces. Some were fortunate enough to have rear access running between the back gardens of adjacent roads to cater for the few families who owned a car. Their garages opened onto these lanes. Getting in and out was never easy but is very difficult now, with larger cars, and households owning more than one vehicle. The more upmarket houses had a garage at the side effectively widening the plot as a whole.

Owners planted ornamental trees where space permitted, to give a country look and many estates had grass verges dotted with trees imparting a rural air. The importance of gardens to the population cannot be emphasised too strongly. Fresh air and healthy outdoor living were the ideal to be aimed for. Even new towns had 'garden city' or garden suburb' tacked on to their names. But whether the garden was a few square metres or half a hectare owner-occupiers endeavoured to turn it into their own Garden of Eden.

Garden shed complete with french doors and electric light.
St Albans

Summary

More and more features showing the influence of Art Deco styles become apparent as you look at the houses. So many quirky little details have been included by builders. Even the most ordinary looking house might include miniature arches over the drainpipe hoppers or a few edges on tiles replacing a single brick.

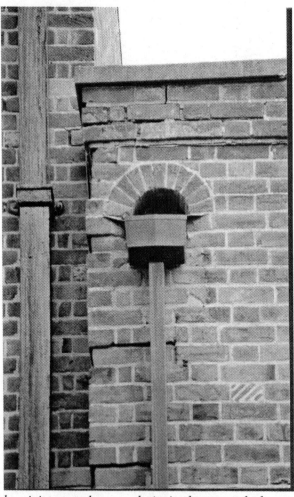

A quirky miniature arch over a drainpipe hopper and edge-on tiles replacing a single brick. Harpenden, Hertfordshire

A detached house was the most desirable but beyond the means of the masses. Topstreet Way, Harpenden

The 'three up, two down' Mock Tudor, suggesting as it did the traditional English home, was easily the most popular, although the detached house was more desirable. The semi-detached house is the common symbol of the era, gaining its popularity over terraced properties because of the privacy afforded by the sideway linking the front and back gardens. The first time owners were free to beautify their homes as they wished. The bold colours of the Jazz Age reached them as two-tone paintwork on almost every bay window. Painters spent hours cutting in green on cream or scarlet on white around each individual pane of glass but today these labour intensive colour schemes are rarely seen. As you walk past pairs of semi-detached houses now, those painted in identical colour schemes look much more balanced than when an owner has 'individualised' one half. A different

Well balanced pair of semi-detached houses.
Harpenden, Hertfordshire

coloured front door is tolerable but different coloured paintwork or rendering unbalances the whole facade and the application of plastic cladding, imitating stonework, to one half of a pair is unforgivable. Where the terraced house is concerned bay windows on both levels were considered sufficient to give individuality to each house and allowed more to be crammed in per acre. Regional variations are few. The Art Deco house does not reveal its situation in the way that stone cottages divulge the contents of the local quarry, but there are some differences. The abundance of Dutch gables in East Anglia is due to its nearness to the continent, which has meant centuries of European influence. In turn the pargetting found all over the region spread across England during the Art Deco years.

The name of a house often reflected its style. Pasadena and Lagoona mimicked the Modernist houses of California, while Casablanca, written as one or two words, adorns many white painted houses. White is followed by Walls, Gates, Ways, Lodge and Lands with unerring constancy. Blue Tiles, Green Tiles and Red Roofs like The Flat Roof House and The Concrete House blatantly state the obvious. More subtle is Broadeaves or the no doubt fully electric Kilowatt. Combinations of the occupiers' names such as Bettern and Donmar were common; whereas Dunroamin and Mon Repos indicate that the proud owners hope that they have reached their last resting place.

The house name - Green Tiles - is taken from the roof.
Old Hunstanton, Norfolk

Garden cities such as Welwyn and Letchworth have absorbed old settlements and succeeded in blurring the distinction between town and country. While villages which were surrounded by suburbs often became the nucleus of the new development and remain so, indeed the centre of East Barnet is still referred to as the village by many residents.

Contemporary advertisements were revealing. 'A rural district ten miles from Marble Arch,' ran one for the Harrow area, and 'twenty minutes to town' read another. Central London was still to be the focus of life although suburban dwellers were supposedly living in the country.

H.L.Bowers advertisement described Ruislip Station Estate as 'On all sides are green fields and pleasant hedgerows. The climate is mild and equable; the air is healthy and invigorating, whilst unlimited facilities for outdoor recreation obtain and particularly liberal educational and shopping facilities exist.' Other advertisements showed people sitting in their front gardens which would be an exceptional sight now. Art Deco gripped the country in the 1930's. The same contrasting features of the London suburbs can be seen throughout the country in towns the size of Birmingham and Bristol down to small villages. Estate agents' literature usually emphasised the double advantages of living in the suburbs with their tree lined avenues and having all modern conveniences at hand. Unfortunately green, tree lined, avenues no longer impart the country setting originally intended because lack of garages means so many are crowded with parked cars.

Outside healthy outdoor living took precedence, while indoors family life centred around the fireplace, usually of brick or tiles. The emphasis was on hearth and home. The family was all important. Houses that seem ordinary now were luxurious then. Imagine moving from a place with a single cold tap in the kitchen and no bathroom to one with an Ideal boiler providing hot water for both.

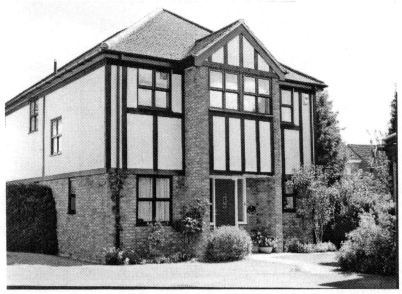

Mock Tudor is being re-worked once again by current builders

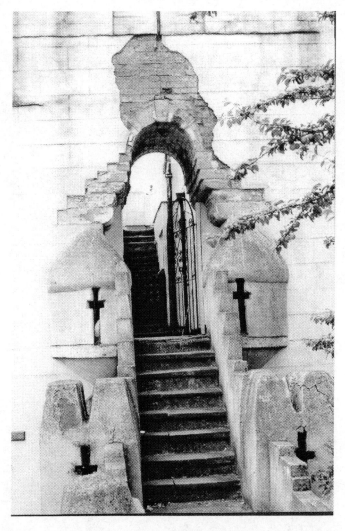

Even a sem-ruined castle is on offer for the romantics in Colindale, London

To home owners used to the vagaries of gas lighting electricity was still a novelty, so lights were a feature in ceilings, on walls, newel posts and out in the gardens. If proof is needed that these houses are now historic it is visible on many present day developments where after decades of post war modernism traditional styles are being re-worked once again. Tacked on timbers adorn new houses in all parts of the country. Art Deco houses have come of age and with the dawn of the new century many owners are restoring the original style of their homes rather than modernising them in other ways.

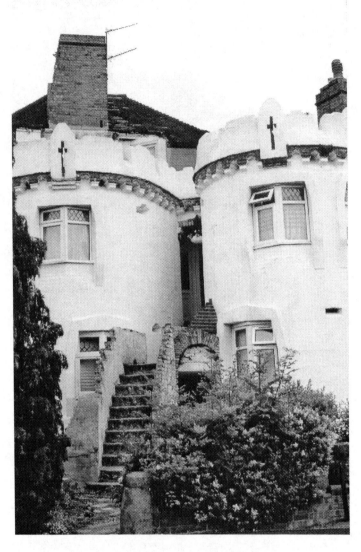

An Englishman's castle. Colindale.
The roof level door opens onto a terrace

The ability to buy houses was a tremendous boost to society and changed it in a subtle way, by acknowledging that home ownership need not be just a 'castle in the air'. Indeed a few Art Deco houses were built in the form of castles in Colindale, North London, where the architect Ernest Trobridge had experimented in the Twenties with

timber framed houses with thatched roofs some of which remain. But by building flats in the guise of mediaeval fortresses in the Thirties he proved that any Englishman's home could truly be a castle.

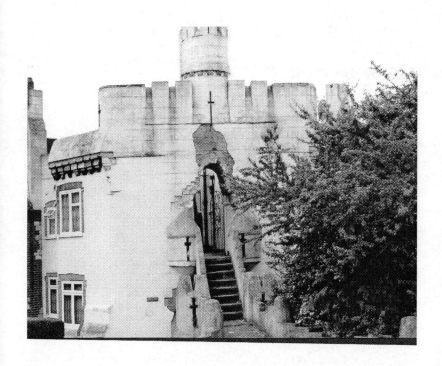

An Englishman's castle. Buck Lane, Colindale

Index

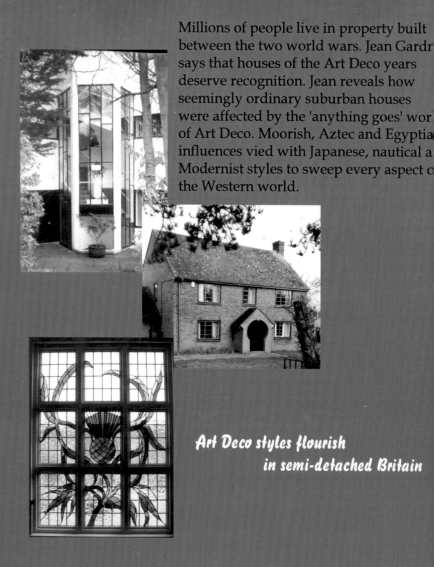

Millions of people live in property built
between the two world wars. Jean Gardr
says that houses of the Art Deco years
deserve recognition. Jean reveals how
seemingly ordinary suburban houses
were affected by the 'anything goes' wor
of Art Deco. Moorish, Aztec and Egyptia
influences vied with Japanese, nautical a
Modernist styles to sweep every aspect c
the Western world.

Art Deco styles flourish
in semi-detached Britain

ISBN 1898030715

9 781898 030713

90000>

Rhapsody
www.author.co.uk

£11.95